IMAGES
of America

BRIDGES OF
PORTLAND

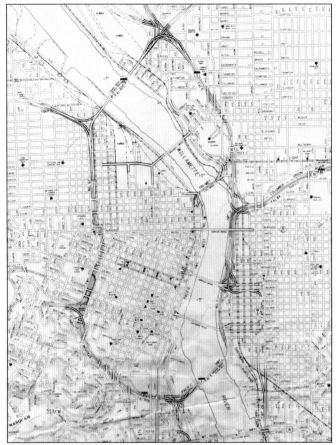

This June 1988 map illustrates why Portland is called a "city of bridges." Eight bridges cross a three-mile section of the Willamette River shown on this map, but a total of 15 bridges cross the Willamette River and the Columbia River within Portland. Portland's collection of bridges is an important transportation link, but it is also important from a historical perspective. Portland's collection of bridges is unique in many respects. Diverse structure types are represented, including numerous drawbridges. Several of the spans set records when they were built. One of the bridges is the world's only double-deck, vertical-lift bridge capable of lifting the lower deck independently of the upper deck, and another is a rare example of a Rall bascule-type drawbridge. In Portland, the evolution of bridge design and construction between 1908 and 1983 is showcased. The work of a number of nationally recognized bridge engineers is represented as well. And, most importantly, the collection provides 15 automotive and rail transportation links for the Portland area. (Courtesy Oregon Department of Transportation [ODOT].)

ON THE COVER: This aerial photograph looking north into Portland shows six of Portland's Willamette River bridges as they appeared in 1930. Shown in order from upstream at the bottom of the page to downstream at the top of the page are the 1926 Ross Island Bridge, the 1910 Hawthorne Bridge, the 1905 Morrison Bridge, the 1926 Burnside Bridge, the 1912 Steel Bridge, and the 1913 Broadway Bridge. Not shown are the 1925 Sellwood Bridge upstream, the 1908 Willamette River Railroad Bridge downstream, and the St. Johns Bridge, which was under construction farther downstream. Also not shown are the Interstate Bridge, and the Columbia River and Oregon Slough Railroad Bridges. These bridges all contributed greatly to the growth of Portland while accommodating the navigation that made it a major shipping point for the Pacific Northwest's wheat, lumber, and other commodities. (Courtesy author.)

IMAGES
of America

BRIDGES OF PORTLAND

Ray Bottenberg

ARCADIA
PUBLISHING

Published by Arcadia Publishing
Charleston SC, Chicago IL, Portsmouth NH, San Francisco CA

Printed in the United States of America

Library of Congress Catalog Card Number: 2006935600

For all general information contact Arcadia Publishing at:
Telephone 843-853-2070
Fax 843-853-0044
E-mail sales@arcadiapublishing.com
For customer service and orders:
Toll-Free 1-888-313-2665

Visit us on the Internet at www.arcadiapublishing.com

*For my wonderful Mom and Dad, thank you for all your love and
support through the years.*

CONTENTS

ACKNOWLEDGMENTS

I wish to thank Robert W. Hadlow, Ph.D., of the Oregon Department of Transportation for providing much information and many helpful suggestions and for reviewing the nearly completed book. I also wish to thank the City of Portland's Stanley Parr Archives and Records Center, the Oregon Department of Transportation, the Oregon State Archives, the Multnomah County Library, the Michigan Department of Transportation, Multnomah County, ESCO Corporation and Hank Swigert, Modjeski and Masters, Incorporated, the Nelson Family Archive, Stephen Ingham, Inc., Stephen Kenney Jr., Dusty Schmidt, Virgil Reynolds, Curtis B. Cryer, Julie Albright, and Robert W. Hadlow for making photographs available for use in this volume.

And I would also like to thank the following individuals for the guidance and assistance they provided, which made this volume possible: Brian Johnson of the City of Portland's Stanley Parr Archives and Records Center; Tom Ohren, Pat Solomon, Frances Nichols, Laura Wilt, Frank Nelson, Lloyd Bledsoe, and Greg Westergaard of the Oregon Department of Transportation; Cathey Kramer, Cheryl Strubb, and Gail Anderson of Multnomah County; Jodi Waldner-Biesanz and Natalie Maciukenas of ESCO Corporation; Michael Britt and Linda Greist of Modjeski and Masters, Incorporated; Chris Smith and Linda Norris of the Michigan Department of Transportation; David Wendell, Todd Shaffer, and Tim Backer of the Oregon State Archives; and Julie Albright, my editor at Arcadia Publishing.

INTRODUCTION

The city of Portland began in 1845 with the flip of a coin by the city's founders, Asa Lovejoy and Francis Pettygrove. Lovejoy was from Massachusetts and wanted to name the city "Boston," but Pettygrove was from Maine and the coin toss gave him the right to name the city "Portland." The city grew, and in 1848, Israel Mitchell established a horse-powered ferry across the Willamette River. In 1852, Mitchell's ferry was replaced with the steam-powered Stark Street ferry, operated by J. B. Stevens. By the 1860s, the need for a bridge became increasingly acute, and about 1870, pressure began to build for a Willamette River Bridge.

After much political agitation, challenges by ferry and navigation interests, and numerous false starts, the Willamette Bridge Company was formed in 1886 and gained permission to build the Morrison Street Bridge. The Morrison Street Bridge was a 1,650-foot timber bridge—the largest west of the Mississippi—with a wrought-iron swing span, and it was designed and built by the Pacific Bridge Company. It opened to traffic on March 2, 1887, with a schedule of tolls varying from 5¢ for pedestrians to 20¢ for two horses and a driver with the driver's family riding for free.

The Morrison Bridge was followed shortly by the Steel Bridge, built in 1888 by the Oregon Railway and Navigation Company, a subsidiary of the Union Pacific Railroad, in the vicinity of Holladay Street. Being the first steel bridge on the West Coast earned it the name "Steel," which distinguished it from then-common wrought-iron bridges. The Steel Bridge was a swing span with a lower deck for railway traffic and an upper deck for vehicular traffic.

Construction of the Madison Street Bridge began in February 1890, and the bridge was completed in June 1891. The Madison Bridge, a timber bridge with a timber swing span, was built as a private venture for toll revenue.

In 1891, the state legislature authorized a committee of eight Portland citizens, with J. L. Sperry as chairman, for "the purpose of buying, building, or leasing one or more suitable and commodious bridges across the Willamette River within the confines of Portland." The committee first purchased the Madison Bridge for $145,000 on November 18, 1891, and removed the tolls. Then it unsuccessfully attempted to purchase the Morrison Bridge, and proposed building two new bridges, one between the Morrison Bridge and the Steel Bridge, and one at Knight and Quimby Streets in Albina. When the Portland office of the Army Corps of Engineers denied both bridges, the committee appealed directly to Secretary of War Stephen Elkins and eventually was able to award a contract for construction of the Burnside Street Bridge to Bullen Bridge Company on October 15, 1892. The 1,621-foot wrought-iron-and-steel Burnside Bridge, with swing span, was opened for traffic on July 4, 1894, without tolls.

The Madison Bridge deteriorated rapidly, and in 1900, it was extensively rebuilt with all new timber members and a new reinforced swing span. The Morrison Bridge also deteriorated, and in 1904, bids were taken for construction of its wrought-iron-and-steel replacement. The winning bid was far from the lowest submitted, and recurrent events such as this led to reforms that brought in nationally known designers from outside of Portland for future bridges, and eventually led the state legislature to transfer the City of Portland's bridges to Multnomah County. Thus, when the Steel Bridge and the Madison Bridge were replaced by the second Steel Bridge and the Hawthorne Bridge, the new bridges were designed by consulting engineers Waddell and Harrington of Kansas City, Missouri, and the Broadway Street Bridge was designed by consulting engineer Ralph Modjeski of Chicago. Modjeski also designed three large swing-type drawbridges for the Northern Pacific Railway on the Columbia River and Oregon Slough between Portland and Vancouver, Washington, and on the Willamette River near Linnton, all of which were built in 1908.

Multnomah and Clark Counties jointly built the Interstate Bridge over the Columbia River between 1915 and 1917, connecting Vancouver and Portland. This major bridge was also designed

by Waddell and Harrington, who dissolved their partnership during the project, and John Lyle Harrington completed the project.

During the 1920s, Multnomah County embarked upon an ambitious bridge-building program, planning to replace the Burnside Bridge and construct the Ross Island Bridge near its namesake island and the Sellwood Bridge near Spokane Street. One of Multnomah County's engineers, Robert Kremers, resigned to design the three bridges and partnered with Ira G. Hedrick, a former associate of John Alexander Low Waddell, when citizens questioned Kremers's experience. Later, the county commissioners awarded the contract to build the Burnside Bridge to a bidder who had not submitted the lowest bid. This irregularity resulted in the arrest and indictment of all three county commissioners and their recall by the voters. The new county commissioners hired consulting engineer Gustav Lindenthal of New York to rework Hedrick and Kremers's designs, and the bridges were built under new contracts.

Just before the crash of 1929, Multnomah County began construction of the St. Johns Bridge to connect Linnton and St. Johns. The bridge was designed by consulting engineers Robinson and Steinman of New York. Construction was completed in 1931 as the grip of the Great Depression tightened. The St. Johns Bridge is Portland's only suspension bridge, and when completed, it was the largest suspension bridge west of the Mississippi River, with a 1,207-foot main span.

After the Great Depression and World War II, the next bridge project was the 1958 replacement of the slow-opening Morrison Bridge with a double-leaf, bascule-type drawbridge similar in operation to the Burnside Bridge. The replacement Morrison Bridge was designed by consulting engineers Sverdrup and Parcel of St. Louis, Missouri, and by Moffatt, Nichol, and Taylor of Portland.

Also in 1958, the Oregon State Highway Department, working with the Washington Division of Highways, added a twin to the Interstate Bridge and altered the original bridge to allow more marine traffic to pass without opening the bridge. The alterations, which included replacing two of the 275-foot trusses with one 550-foot truss and raising the bridge, were designed by Oregon State Highway Department engineers.

The Marquam Bridge, a double-deck, steel-cantilever truss located between the Ross Island and Hawthorne Bridges, was designed by Oregon State Highway Department engineers to close the final link in Interstate 5 and to make the freeway continuous from the California border to the Columbia River. The appearance of the utilitarian bridge, completed in 1966, prompted a formal protest from Portland's arts community.

Following the controversy over the design of the Marquam Bridge, the Oregon State Highway Department hired Parsons, Brinckerhoff, Quade, and Douglas of New York to design the Fremont Bridge to carry Interstate 405 over the Willamette River north of the Broadway Bridge while presenting an aesthetic appearance. The high-strength-steel, tied-arch design, with its record-setting 1,255-foot main span, opened for traffic in 1973.

The culmination of at least 30 years of planning between the Oregon State Highway Department and the Washington Department of Transportation, the Glenn L. Jackson Memorial Bridge opened for traffic in 1982, completing Portland's eastside bypass, Interstate 205. The northern channel portion of the post-tensioned, concrete-box-girder structure, which has a main span of 600 feet, was designed by Sverdrup and Parcel and Associates of Bellevue, Washington, while the south channel bridge was designed by Oregon State Highway Department engineers.

The result of all these events is an outstanding collection of major bridges in Portland, representing diverse structure types and many nationally recognized bridge designers, and carrying a tremendous amount of traffic.

GLOSSARY

BASCULE-TYPE DRAWBRIDGE: A movable bridge type having one (single leaf) or two (double leaf) spans hinged at a pier, to open upward away from the navigation channel (see Burnside and Broadway Bridges).

BENT: A vertical structure supporting the spans of a bridge, typically on land.

CAMBER: The built-in upward deflection of a structure that compensates for the downward sag of the structure due to its own weight.

CANTILEVER: A type of truss in which the main span is supported by two piers at each end (see Marquam Bridge). It also refers to a type of beam that overhangs past its supports.

COFFERDAM: A temporary structure, typically made by driving sheet piling around an in-water work area such as in bridge pier construction, that is pumped out to dewater the work area.

DEAD LOAD: The self-weight of the bridge components.

DECK: The portion of the bridge structure that provides a roadway surface to carry traffic.

FALSEWORK: A temporary structure used to support concrete forms during construction.

FENDER: The structure used to protect bridge piers against errant vessels and drift.

HYDROSTATIC PRESSURE: Pressure caused by the weight of a fluid such as water above and around a submerged structure, acting in all directions and tending to collapse submerged structures.

LIVE LOAD: The weight of vehicles, persons, and cargoes carried by the bridge.

PIER: The vertical structure supporting the spans of a bridge, typically in water.

PILING: A long, slender foundation component, typically timber, driven into the soil.

PLATE GIRDER: A type of steel beam having top and bottom horizontal flanges connected by a vertical web, fabricated from pieces of steel plate. Early plate girders were riveted together with steel angles connecting the pieces of plate, while modern plate girders are welded together directly.

PORTAL: The entryway from the open roadway into an overhead bridge structure.

POST-TENSIONING: A method of strengthening concrete components by providing reinforcing strands that are put under stress after the concrete is in place. Post-tensioning increases a component's load-carrying capacity and its durability.

PRESTRESSED CONCRETE: Concrete components strengthened by providing reinforcement that is under stress when the concrete is cast. Prestressing increases a component's load-carrying capacity and its durability.

REINFORCED CONCRETE DECK GIRDER: A bridge-structure type with girders and floor beams cast integrally with deck.

RIPRAP: Large rock placed around bridge piers and other underwater structures to protect them from the scouring action of rivers and tides, which tend to undermine foundations.

SEAL: The first layer of concrete poured at the bottom of piers to seal water out of the cofferdam.

SHEAVE: A wheel with a grooved rim, used as a pulley.

SHEET PILING: Wooden planks or corrugated steel driven into soil, typically used to construct cofferdams and retaining walls.

SHORING: A temporary structure provided to prevent the collapse of cofferdams or excavations during construction.

SPAN: The distance between vertical supports.

STRESS: Force per unit area carried by a structural member. Bridge designers size structural members so that the stresses due to loads the bridge must resist are less than allowable stress values for the material.

SWING-TYPE DRAWBRIDGE: A movable bridge type having one span that pivots around a central pier, providing two navigation channels (see Columbia River Railroad Bridge).

TIED ARCH: An arch bridge structure type in which the desk resists the tendency of the arch ribs to push the main bridge piers apart. Hangars support the deck from the overhead arch ribs.

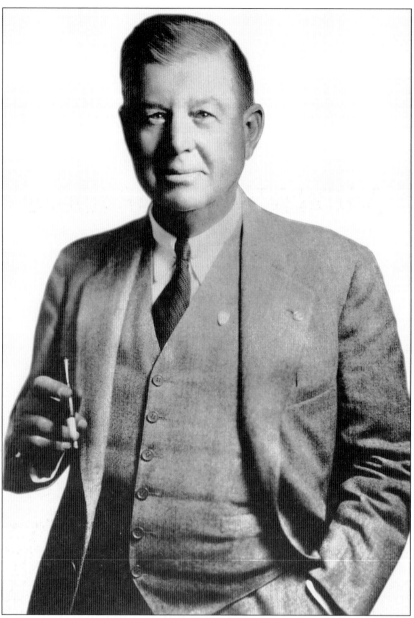

Charles F. Swigert, the longtime head of Pacific Bridge Company, is shown here in 1913. He began working for Pacific Bridge in 1881 on an assignment to finish the construction of a troubled deepwater pier project in Ocos, Guatemala. In 1887, he went to Portland to oversee construction of Portland's first Willamette River bridge, the Morrison Street Bridge. Other bridge projects completed by Pacific Bridge include the first bridge over the Willamette River at Oregon City, and the piers for the Burnside, Ross Island, St. Johns, Interstate, Longview, and Golden Gate Bridges. Swigert also founded and headed the City and Suburban Railway Company of Portland, a streetcar company, and was president of the Port of Portland and a director of Portland General Electric. In 1913, the Portland Bronze and Crucible Steel Company reorganized as Electric Steel Foundry, and shortly afterward Swigert became president of Electric Steel Foundry, the predecessor of ESCO Corporation. (Courtesy ESCO Corporation.)

One

MORRISON BRIDGE

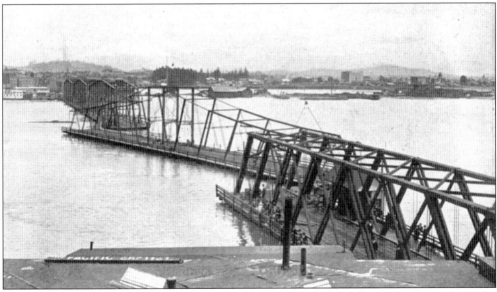

With Mount Hood in the background, Portland's first Morrison Street Bridge endures the snowmelt-laden flood of June 1894. The fenders meant to protect the swing span from errant vessels and drift are entirely covered by the floodwaters. The flood is close to the level of the bridge deck, the swing span is in an odd position—not fully opened and not fully closed—and some of the handrail on the upstream side appears to be missing. The flood of 1894, at 33 feet above low water, exceeded the levels of historic floods during 1862, 1871, 1876, and 1880, with the worst previous flood being 28.3 feet in 1876. The 1894 flood began in May, reaching 25 feet and encroaching on Portland's streets on May 27, peaking at 33 feet on June 7 and leaving the streets on June 24. (Courtesy City of Portland Archives.)

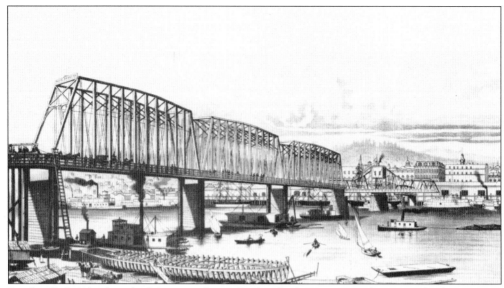

Portland's first bridge, the Morrison Street Bridge, built in 1887, is shown in this busy scene. The sign above the portal reads "Pacific Bridge Co.," indicating the designers and builders of the bridge. Pacific Bridge Company of San Francisco sent 25-year-old Charles F. Swigert to Portland in 1886 to open a branch office. Swigert helped design the bridge and supervised its construction. (Courtesy Multnomah County Library.)

The first Morrison Bridge and Mount Hood are shown in this 1892 bird's-eye view looking toward the east. The bridge was constructed of timber, and its swing span is nearly obscured by buildings along the western waterfront. The large elevated structure south of the bridge on the east side is a railroad trestle. (Courtesy City of Portland Archives.)

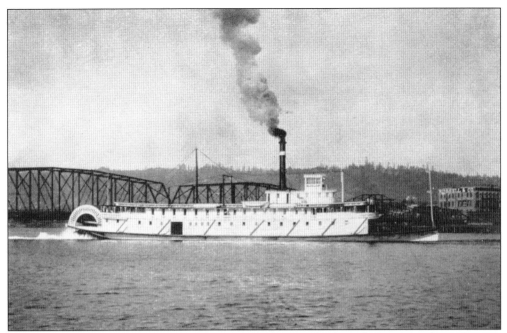

The first Morrison Bridge and the steam-powered sternwheeler *Telephone* are shown here in 1892. The bridge is shown with the swing span closed to marine traffic. The *Telephone* plied the Columbia and Willamette rivers between Portland and Astoria, Oregon, for the Columbia River and Puget Sound Navigation Company. (Courtesy City of Portland Archives.)

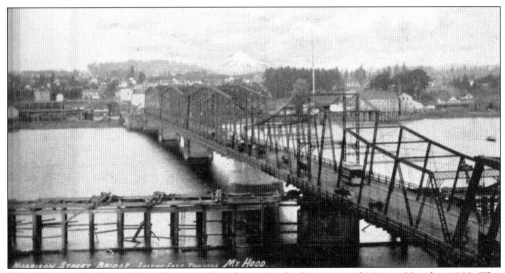

The Morrison Bridge is shown here in closed position looking toward Mount Hood in 1892. The wrought-iron swing span is 310 feet long, the timber span to the left is 160 feet long, and the three timber spans to the right are each 260 feet long, making a total length of 1,250 feet. (Courtesy City of Portland Archives.)

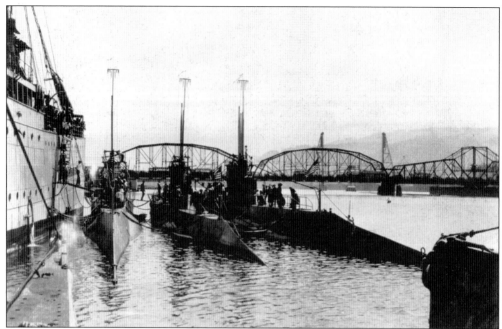

The Morrison Bridge was replaced with a heavier wrought-iron-and-steel, swing-type drawbridge of similar length in 1905. This view looking south shows the second Morrison Bridge carrying heavy traffic, including streetcars, with three U.S. Navy submarines in the foreground. The second bridge cost $331,343 plus extra expenses of $52,000. (Courtesy Nelson family archive.)

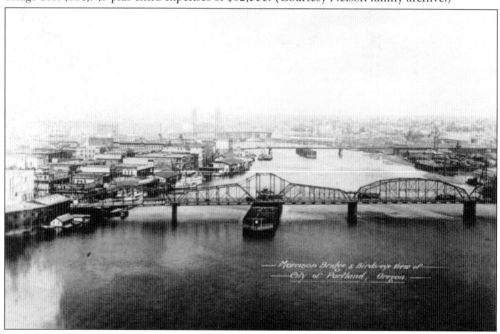

The second Morrison Bridge is shown after being in service for 13 years in this 1918 view looking toward the north. The large timber fender at the center of the swing span protects the swing span while the bridge is open to marine traffic. The Burnside Bridge and the Steel Bridge are also visible. (Courtesy City of Portland Archives.)

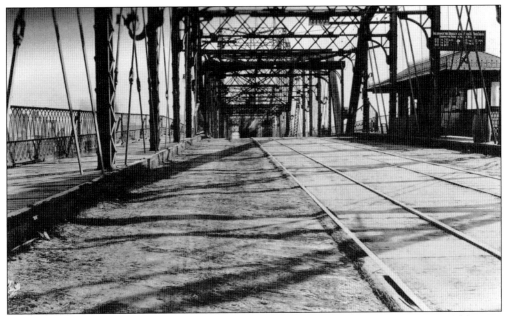

The Morrison Bridge's timber deck is worn in this 1920 photograph. The gate man's house is visible to the right near the gate that is closed to block traffic when the bridge is open to marine traffic. A sign indicates that the bridge will not open to marine traffic during certain hours. (Courtesy Multnomah County Library.)

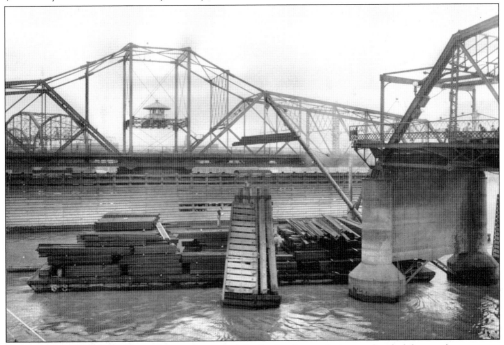

Approximately 250,000 board feet of ties and deck planks are being unloaded from a barge onto the Morrison Bridge during deck replacement work in this 1939 photograph. Approximately 467,858 board feet of timber treated with 50 percent creosote and 50 percent petroleum oil were supplied by Pope and Talbot Lumber Company. (Courtesy Multnomah County.)

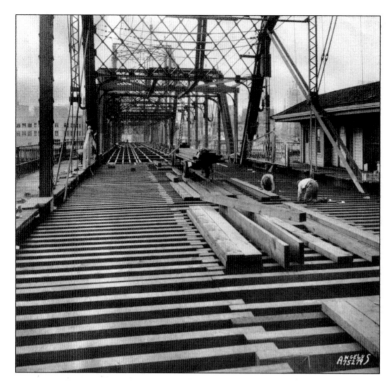

Ties are being placed in preparation for deck planks in this 1939 photograph. The deck replacement work started in January 1939 and was finished in March 1939. The gate man's house and the traffic gates that block traffic during closures for marine traffic are visible. (Courtesy Multnomah County.)

Planks to keep asphalt paving out of new streetcar tracks during the deck replacement work are being attached to new deck planks by workers in this 1939 view. Workers at right are replacing sidewalk planks. The deck-replacement work was part of a larger project that included replacement of east and west approaches. (Courtesy ODOT.)

Workers are spreading asphalt on the new deck as a roller waits on them in this 1939 photograph. The deck replacement consumed approximately 300 cubic yards of asphalt and was part of a Public Works Administration project. The deck work was completed by Parker-Schram Company of Portland for $93,770.50. (Courtesy Multnomah County.)

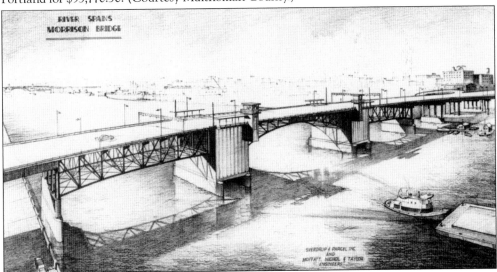

A preview of the third Morrison Bridge was provided in this artistic rendition by the designers, Sverdrup and Parcel, Inc. and Moffatt, Nichol, and Taylor Engineers, dated March 15, 1953. While the structural layout is quite similar to the Burnside Bridge, the architectural treatment is austere by comparison, with modern handrails, operator's houses that resemble airport control towers, and modern detailing of the piers and structural steel. (Courtesy ODOT.)

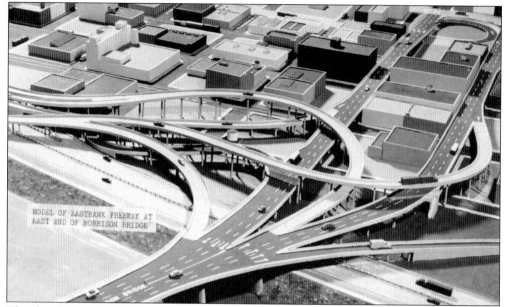

This detailed model of the east interchanges of the Morrison Bridge shows the Eastbank Freeway, now known as Interstate 5, passing under the Morrison Bridge's ramps. Southeast Morrison Street and Southeast Belmont Street were extensively modified for several blocks, with the bridge approaches "shoehorned" between tall buildings. (City of Portland Archives.)

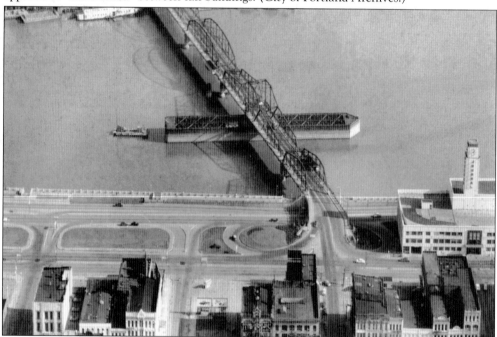

This is an aerial photograph of the Morrison Bridge looking toward the southeast, taken February 1955. The 1941 Harbor Drive project shortened the west truss, which was no longer symmetrical, and rebuilt the west approaches. The barge just north of the fender system is likely performing subsurface boring to determine foundation needs for the third Morrison Bridge. (Courtesy Multnomah County.)

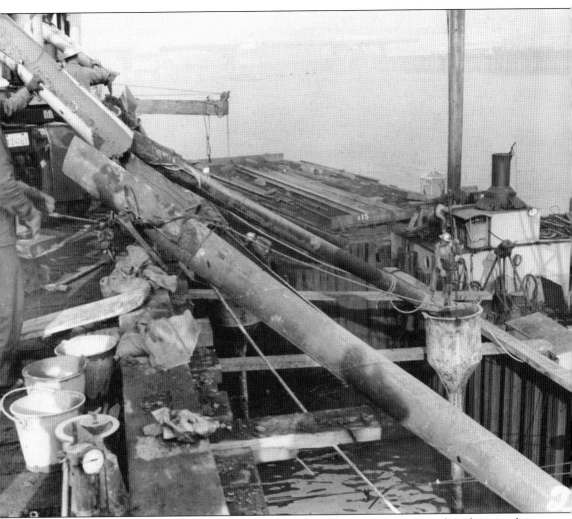

A seal pour for one of the river piers of the Morrison Bridge is under way in this photograph, dated February 15, 1956. This pier is being built within a cofferdam made of steel-sheet piling. The seal is a layer of concrete at the bottom of the pier, which helps keep water out of the cofferdam. The seal is poured underwater after the foundation pilings are driven, using tremie tubes. The tremie tubes, seen here with a funnel shape at the top, minimize the harmful effects of excess water on wet concrete by delivering the wet concrete directly to the bottom of the pier. After the seal concrete cures, the water is pumped out of the cofferdam and workers enter the cofferdam to clean off the top of the seal and begin building the reinforced-concrete structure of the pier. (Courtesy Multnomah County.)

During pumping of the east main-pier cofferdam, two of the struts, which resist the hydrostatic pressure of the water around the cofferdam, buckled. The buckled steel struts are shown in this view looking down into the pier. Adjacent struts prevented total failure of the cofferdam, and new struts were installed. (Courtesy Multnomah County.)

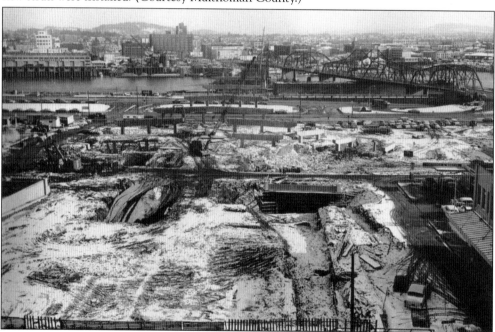

The west-approach construction site was dusted with snow in January 1957, when the photographer went to the eighth floor of the Panama Building to take this photograph looking toward the southeast. A bridge abutment is being built in the excavation in the right foreground, and another abutment is built but not backfilled at left. (Courtesy Multnomah County.)

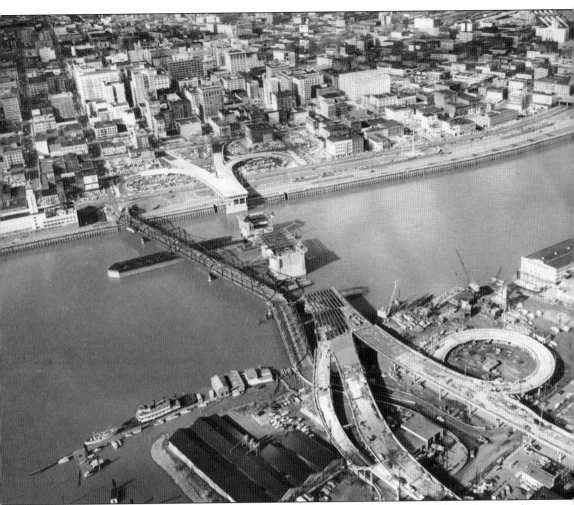

The river piers, the east approaches, and the west approaches are shown in this aerial photograph looking toward the northwest. The east span of the earlier Morrison Bridge has been relocated to the south to make room for the new bridge. Piers for each end of the east span were built by General Construction Company, with pilings for the west pier driven through holes in the timber deck. The east span was strengthened so that it could be carried by barges, and on June 20, 1957, two barges were placed under the span and lifted the span as their ballast was pumped out. The barges carried the span to the new piers and were slowly ballasted to lower the span into place. A wedge-shaped section of deck was added at the west end of the span, and the east approach was already complete. The detour opened for traffic on June 26, 1957. (Courtesy Multnomah County.)

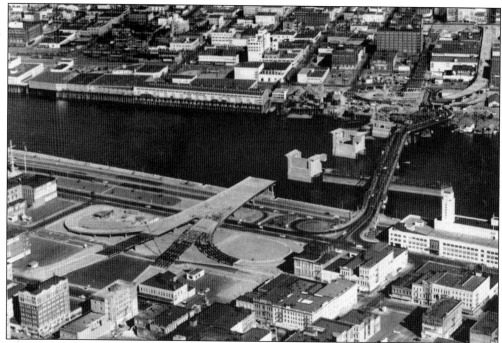

The river piers, the east approaches, and the west approaches are shown in this aerial photograph looking toward the east. This view illustrates how the west main pier was located to match the established navigation channel of the earlier bridge and to just miss the swing span when the earlier bridge was opened. (Courtesy Multnomah County.)

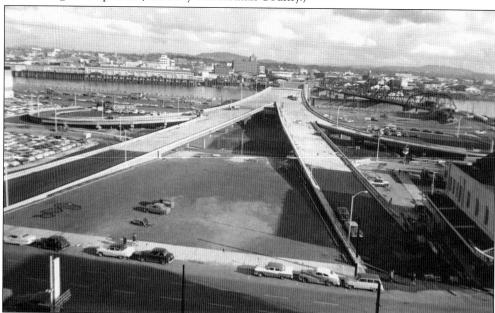

The west approaches are nearly complete in this photograph looking southeast. The west approaches were completed at a final cost of $1.25 million. On October 22, 1956, there was a fatal accident when a Mercer Steel Company employee identified as Davies was covered by an earth slide while checking reinforcement in a footing. (Courtesy Multnomah County.)

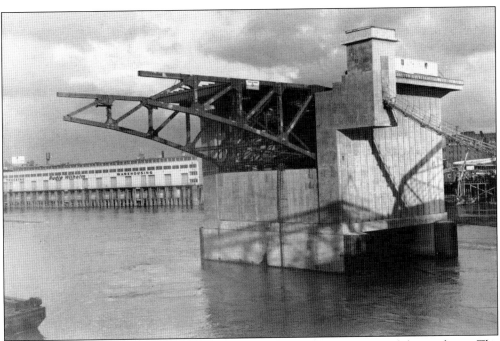

The east bascule leaf is partially completed in this photograph looking toward the northeast. The steel river spans, including the bascule leaves, were fabricated and erected by American Bridge Division of United States Steel Corporation as identified by the sign. American Bridge provided 937 feet of the bridge for $2.27 million. (Courtesy Multnomah County.)

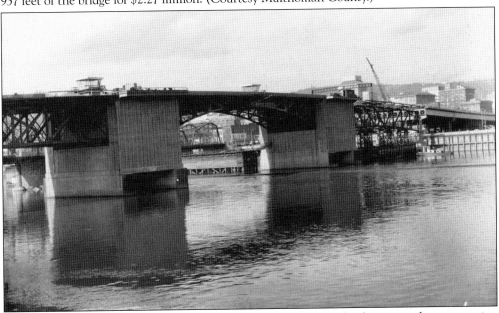

The Morrison Bridge's movable spans appear complete and the west fixed span is under construction in this view, dated April 3, 1958. The west fixed span is being erected on temporary towers mounted on a barge. A sign bridge spanning all six traffic lanes and both six-foot sidewalks have been installed near the west main pier. The bascule leaves provide a 284-foot span over the navigation channel. (Courtesy Multnomah County.)

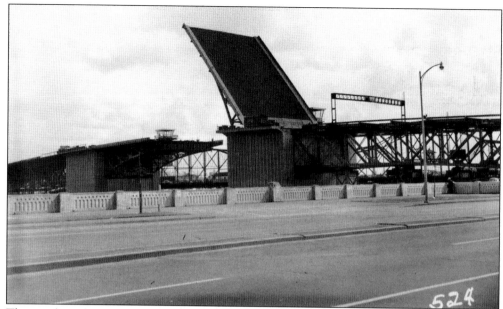

The west bascule leaf opens independently of the east leaf in this photograph, taken May 3, 1958. The bridge operating machinery was fabricated by Northwest Marine and Iron Works of Portland between April and December 1957. This machinery was installed in December 1957 by American Bridge Division of United States Steel Corporation. (Courtesy Multnomah County.)

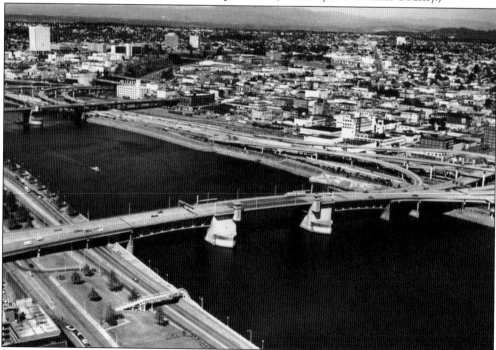

The third Morrison Bridge, opened to traffic on May 24, 1958, is shown here on May 11, 1973. The bridge is a double-leaf, bascule-type drawbridge, similar in structural layout and operation to the Burnside Bridge. The bridge was designed by Sverdrup and Parcel of St. Louis, Missouri, and Moffatt, Nichol, and Taylor, Inc., of Portland beginning in 1954. (Courtesy ODOT.)

Two

STEEL AND MADISON/HAWTHORNE BRIDGES

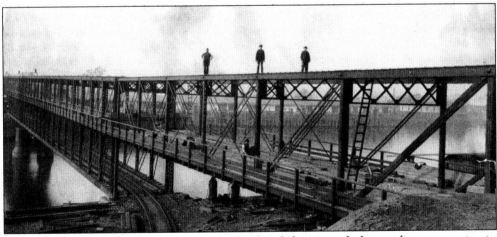

The Steel Bridge's lower deck appears completed and the upper deck is under construction in this photograph from the east end of the bridge. Built by the Oregon Railway and Navigation Company (OR&N) to connect its Albina yards with downtown Portland, it was the first bridge made of steel on the Pacific coast. Construction began in 1886, the lower deck opened to rail traffic in 1888, and the upper deck opened to public traffic and streetcars in 1889. The bridge began as a proposal by Henry Villard, the founder of the OR&N, in 1883, but was delayed by Villard's resignation in 1884. While many of Villard's grand plans, including a west side rail station and east side railroad shops, were abandoned, the bridge was designed by consulting engineer George S. Morison. The Union Pacific Railroad purchased a majority interest in the OR&N when the bridge was completed. (Courtesy Nelson family archive.)

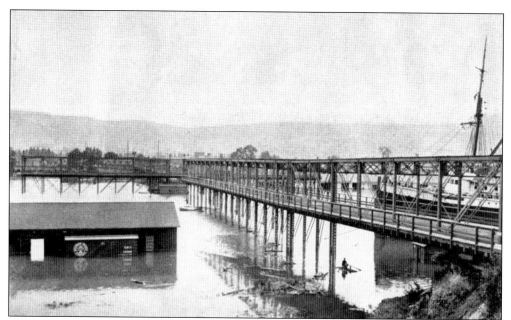

The lower deck of the steel bridge is entirely submerged and a man is rowing a boat over the tracks during the flood of 1894, as seen from the same vantage point as the photograph on page 25. The bridge was left in the open position during the flood, and the bridge operator's house is visible. (Courtesy City of Portland Archives.)

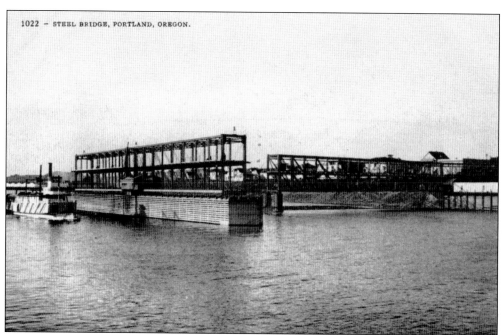

1022 – STEEL BRIDGE, PORTLAND, OREGON.

The original Steel Bridge is shown opened for a riverboat in this early postcard view. This double-deck, swing-type drawbridge, with one deck for railroad traffic and one deck for public traffic, was opened in 1888 and replaced in 1912. Its name reflects the fact that it was built of steel, a novelty in an era when wrought iron was predominant. (Courtesy author.)

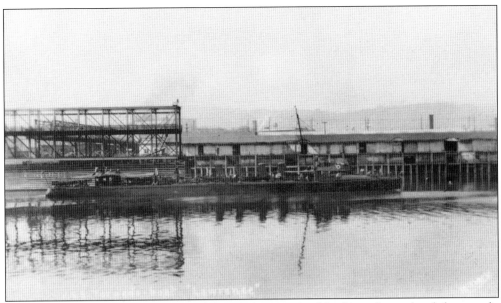

The torpedo boat USS *Lawrence* passes through the open Steel Bridge in this undated photograph. The *Lawrence* was laid down April 10, 1899, by Fore River Ship and Engine Company of Weymouth, Massachusetts; launched November 7, 1900; and commissioned April 7, 1903, with Lt. Andre M. Proctor in command. (Courtesy Nelson family archive.)

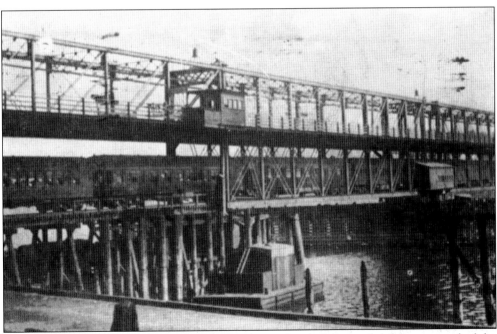

A passenger train crosses the Steel Bridge in this undated photograph of the west end of the bridge. In this view, both the bridge operator's house, near the fender system, and a gate man's house are visible. The lower deck of the bridge is supported on a timber trestle, while the upper deck is supported by a steel truss. (Courtesy Stephen Kenney Jr.)

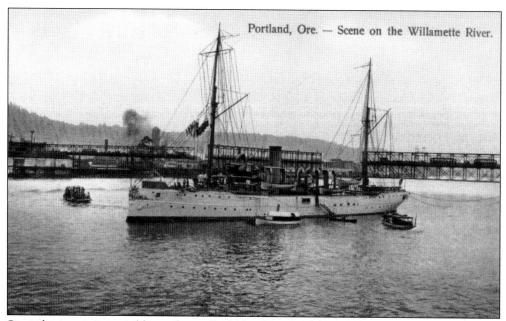

Portland, Ore. — Scene on the Willamette River.

Several streetcars are visible on the upper deck of the Steel Bridge in this photograph of a U.S. Navy ship of Pres. Theodore Roosevelt's Great White Fleet. The streetcar system that ran on the Steel Bridge was an electric railway originated by Charles F. Swigert, the longtime head of Pacific Bridge Company. (Courtesy Stephen Kenney Jr.)

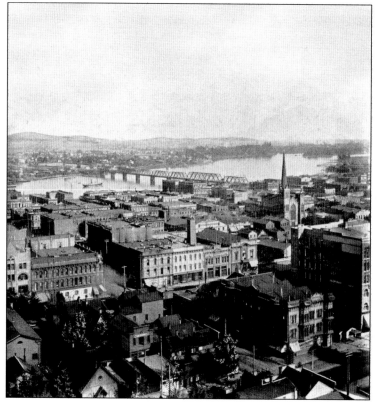

The first Madison Street Bridge is shown in this 1892 bird's-eye view of Portland, looking toward the southeast. The Madison Bridge was a swing-span bridge constructed of timber in 1891 at the site of the present Hawthorne Bridge. The movable span is the larger second truss from the west bank of the Willamette River. (Courtesy City of Portland Archives.)

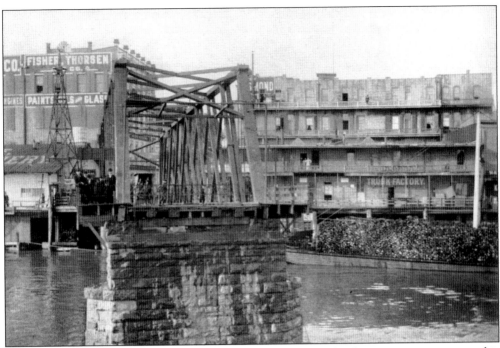

The photographer stayed on the swing span of the Madison Bridge during an opening to get this view of the bridge, c. 1900. In 1899, Portland's Wakefield and Jacobsen contracted to rebuild the bridge, which had deteriorated rapidly since opening in 1891, with a reinforced swing span. The likely occasion for the picture is the reopening of the rebuilt bridge. (Courtesy City of Portland Archives.)

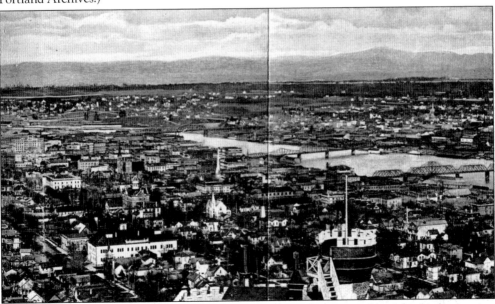

The reinforced swing span of the rebuilt Madison Bridge is shown at right in this bird's-eye view of Portland taken shortly after the turn of the century. The swing span was reinforced by building a tower over the center pier and by connecting iron or steel rods from the tower to the ends of the swing span. (Courtesy City of Portland Archives.)

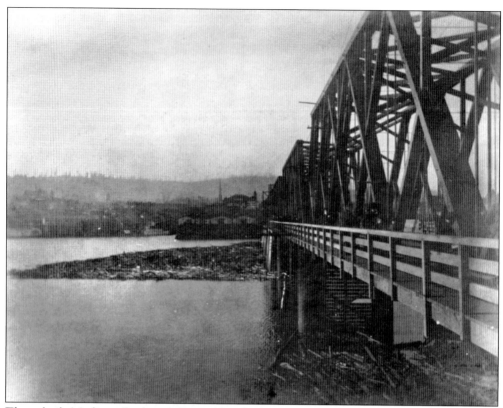

The rebuilt Madison Bridge is shown here looking toward the west in 1901. The $29,975 rebuild included all new timber trusses for the six 190-foot fixed spans east of the 316-foot swing span. A heavy accumulation of driftwood is visible around the bridge. (Courtesy Nelson family archive.)

Robert Wakefield, of Wakefield and Jacobsen, is shown in this early photograph. Wakefield arrived in Portland after several years as the Union Pacific Railroad's superintendent of tracks and bridges. He went on to build many major bridges in Portland, including portions of the Hawthorne Bridge, which replaced the Madison Bridge in 1910, and the second Steel Bridge. (Courtesy Nelson family archive.)

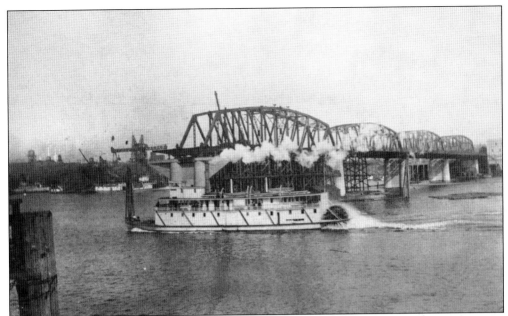

A riverboat passes during construction of the Hawthorne Bridge. The bridge's piers were built by Robert Wakefield, and the steel trusses were fabricated by Pennsylvania Steel and were erected by United Engineering and Construction Company of Portland. Some of the falsework supporting the trusses during construction is visible. United began work in March 1910 and presented the bridge to the City of Portland on December 9, 1910. (Courtesy Stephen Kenney Jr.)

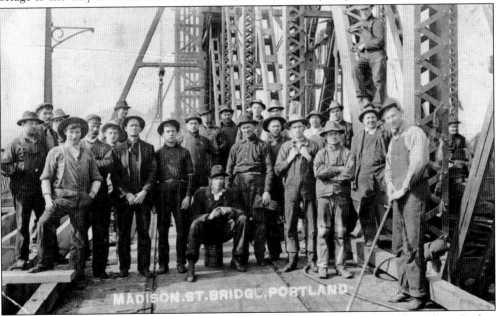

During its construction and early years, the Hawthorne Bridge was known as the Madison Bridge, as was the earlier bridge at this site. The 10-foot sidewalk and handrail are partially complete in this construction-crew portrait dating from 1910. The fifth man from the left has been identified as John J. Doyle, who worked on the bridge until an accident injured both of his knees. (Courtesy City of Portland Archives.)

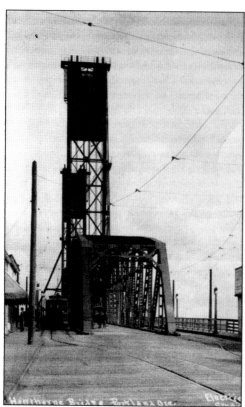

The Hawthorne Bridge carries two inside 10-foot lanes, two outside 12-foot lanes, and two 5-foot sidewalks. A horse-and-buggy uses an inside lane, pedestrians use a sidewalk, and an electric streetcar uses an outside lane with overhead electric lines in this undated early photograph. The bridge has a 244-foot movable span and cost about $500,000 in 1910. (Courtesy Stephen Kenney Jr.)

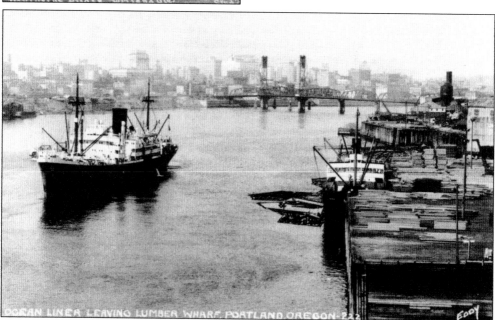

The towers of the Hawthorne Bridge appear as tall as Portland's skyline in this view of an ocean liner leaving a lumber wharf in east Portland. Another vessel is docked at the wharf in this undated view. Manufacturing of lumber to be shipped out was a mainstay of Portland's economy. (Courtesy author.)

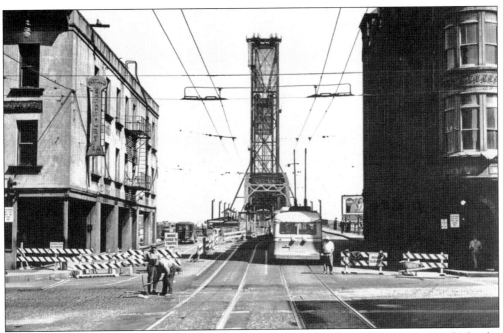

The Hawthorne Bridge is closed to traffic during the 1941 rebuilding of its west approach, for the construction of Harbor Drive, in this view looking east from downtown Portland. Also shown is one of the electric street cars still carried by the bridge. The bridge's 165-foot towers are impressive from this viewpoint. (Courtesy Oregon State Archives.)

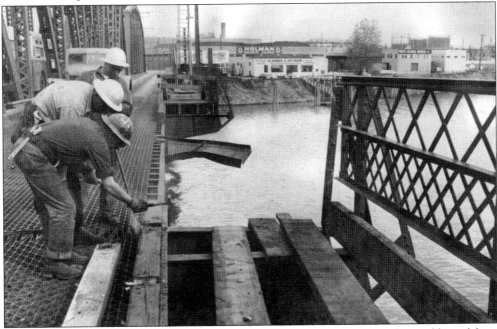

Workers are repairing the damage caused by two errant vessels, lashed together and loosed from a salvage operation by gale force winds, in this April 18, 1957, photograph. The *Lewis A. Milne*, a 14,221-ton ex-navy vessel and the *Chateau Thierry*, a 7,555-ton ex-hospital vessel, hit the bridge on April 14, 1957. (Courtesy Multnomah County.)

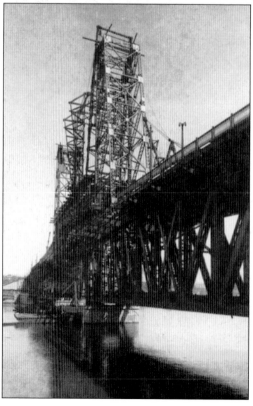

The damage to the sidewalk and handrail in this photograph, dated December 24, 1972, was caused by collision of the ex-carrier *Philippine Sea* with the Hawthorne Bridge. The *Philippine Sea* broke loose from a salvage operation during heavy winds and was carried downstream by winds and current, causing $7,020.25 worth of damage. (Courtesy Multnomah County.)

The replacement Steel Bridge is under construction as a vessel passes in this 1912 photograph. An elaborate traveler handles materials as the lift span is built, and temporary frames are mounted on top of the lift span's towers to lift materials to finish the towers. The lift span was built high above the river to accommodate navigation. (Courtesy Stephen Kenney Jr.)

An unusual arrangement of falsework was used to support the lift span during construction of the replacement Steel Bridge. This scene from 1912 shows the platforms that supported the lift span during construction, a traveler used to handle materials above the lift span, and a ramp from the east end of the bridge used to deliver materials to the lift span. (Courtesy Stephen Kenney Jr.)

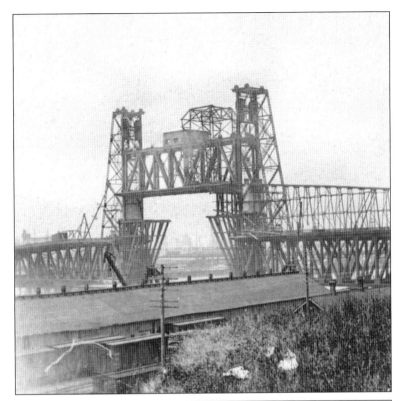

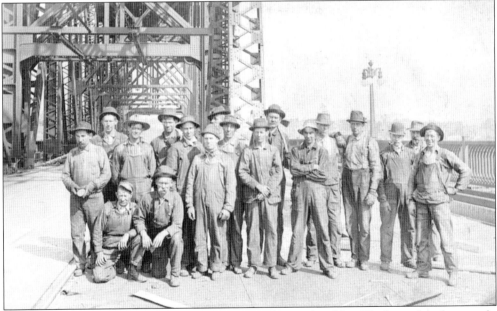

A construction crew poses on the top deck of the nearly completed Steel Bridge in this photograph. The bridge is unique as the only telescoping, double-deck, vertical-lift bridge. It was designed by consulting engineers Waddell and Harrington to allow the bottom deck to be lifted without disturbing traffic on the upper deck. The movable span is 211 feet long. (Courtesy Stephen Kenney Jr.)

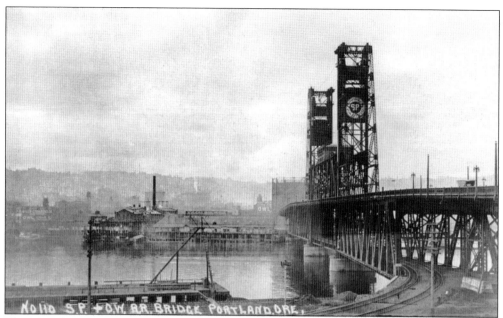

The second Steel Bridge, built in 1912, shows the emblem of Southern Pacific Railroad Company on the east counterweight in this view looking west. The bridge was built by the Oregon-Washington Railroad and Navigation Company and was jointly owned with Southern Pacific until OWR&N's parent corporation, the Union Pacific Railroad Company, purchased Southern Pacific in 1996. (Courtesy author.)

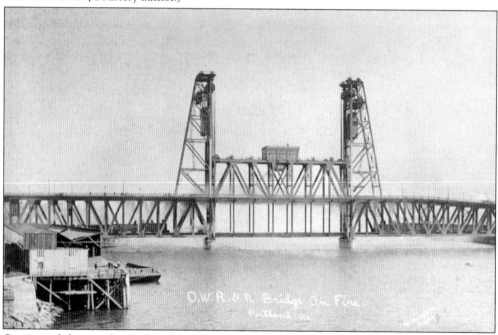

Crews are fighting a fire in the underside of the Steel Bridge's timber upper deck in this undated photograph. By the time the replacement Steel Bridge was built in 1912, the Union Pacific Railroad had consolidated all of its Washington, Oregon, and Idaho subsidiaries to create the Oregon-Washington Railroad and Navigation Company. (Courtesy Stephen Kenney Jr.)

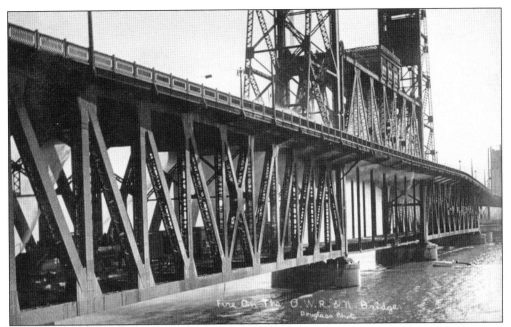

The fire in the Steel Bridge's upper deck is also shown in this undated photograph. It appears that water is being sprayed up to the fire from a train on the lower deck. Presumably the fire was caused by burning material from the exhaust of a locomotive contacting the timber deck. (Courtesy Stephen Kenney Jr.)

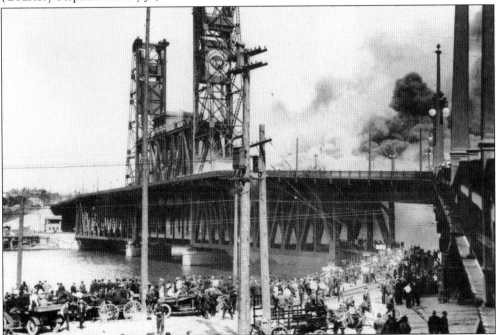

A large crowd gathered when the upper deck of the second Steel Bridge caught fire on July 19, 1913, less than a year after opening to vehicular traffic. The west counterweight shows the emblem of the Oregon-Washington Railroad and Navigation Company, which built the bridge and owned it jointly with Southern Pacific. (Courtesy City of Portland Archives.)

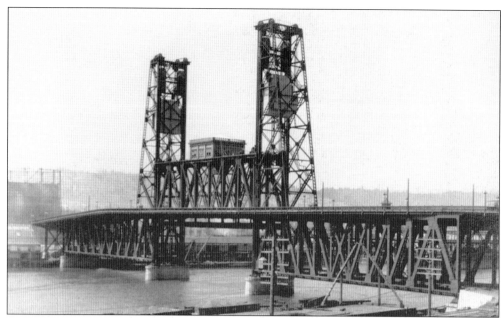

The Steel Bridge is shown with the lower deck raised for marine traffic and the upper deck in place for vehicular traffic in this undated photograph looking toward the northwest. The $1.7 million bridge's piers were built by Union Bridge and Construction Company of Kansas City, Missouri, and the trusses, towers, and lift span were erected by Robert Wakefield of Portland. (Courtesy Robert W. Hadlow, Ph.D.)

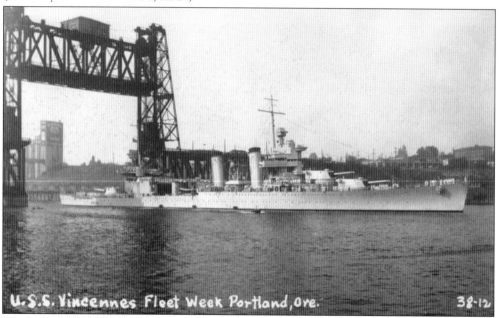

U.S.S. Vincennes Fleet Week Portland, Ore. 38-12

The heavy cruiser USS Vincennes passes under the fully opened Steel Bridge in this undated postcard photograph. The Vincennes was laid down at Quincy, Massachusetts, on January 2, 1934, by Bethlehem Shipbuilding Company, and commissioned on February 24, 1937, with Capt. Burton H. Green in command. The Vincennes was sunk during the Battle of Savo Island in August 1942. (Courtesy Stephen Kenney Jr.)

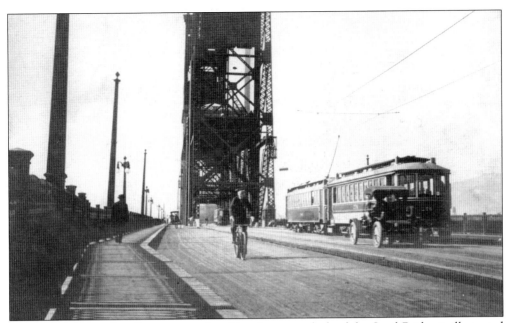

The wide variety of traffic accommodated by the upper deck of the Steel Bridge is illustrated in this undated photograph. A horse-and-buggy shares the roadway with pedestrian, bicycle, and automobile traffic as well as with electric streetcars. Also illustrated are the ornate lighting fixtures provided along the handrails. (Courtesy Nelson family archive.)

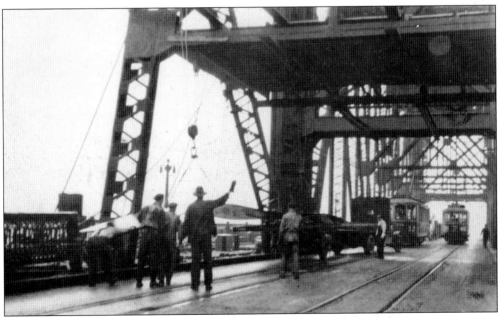

Construction materials are being unloaded from a heavy truck while an electric streetcar waits nearby in this September 9, 1927, photograph. A platform has been installed on the underside of the tower above the roadway, but the nature of the work being done is unknown. (Courtesy Stephen Kenney Jr.)

The waters of the Willamette River nearly touched the trusses of the Steel Bridge when this photograph was taken May 28, 1948, during the infamous Vanport flood. Also visible is a steam-powered locomotive pulling a freight train across the bridge, with exhaust trapped beneath the bridge's upper deck. (Courtesy City of Portland Archives.)

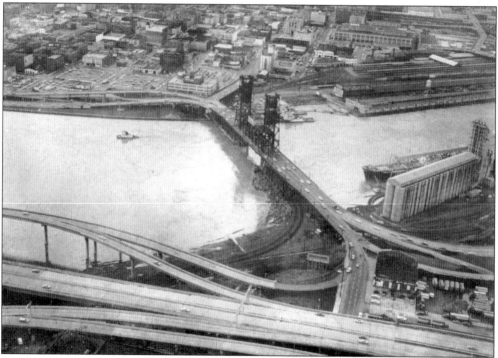

The lower part of the Steel Bridge's trusses is submerged, and drift has collected along the east end of the bridge in this photograph, taken during flooding on December 26, 1964. This view illustrates the bridge's four-lane upper deck, with two lanes through the lift span and one lane on each side of the lift span. (Courtesy ODOT.)

Three

BURNSIDE, ROSS ISLAND, AND SELLWOOD BRIDGES

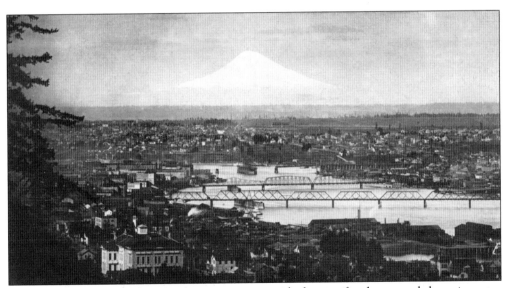

The Burnside Street Bridge is under construction with the east fixed span and the swing span in place in this scene, which includes the Madison Bridge, the Morrison Bridge, and Mount St. Helens in the distance. Secretary of War Stephen Elkins approved the Burnside Bridge on August 24, 1892, bids were soon taken, and the contract for construction was awarded to Bullen Bridge Company on October 15, 1892. W. B. Chase—who had worked for the Northern Pacific Railway Company, had been bridge engineer for construction of the Oregon Pacific Railroad connecting Corvallis to Yaquina Bay, and had been assistant engineer on the Steel Bridge—was appointed chief engineer "on account of his recognized engineering ability and his knowledge of the Willamette River." The 1,621-foot-long Burnside Bridge, which included tracks for the Portland Consolidated Street Railway Company, opened for traffic on July 4, 1894. (Courtesy Nelson family archive.)

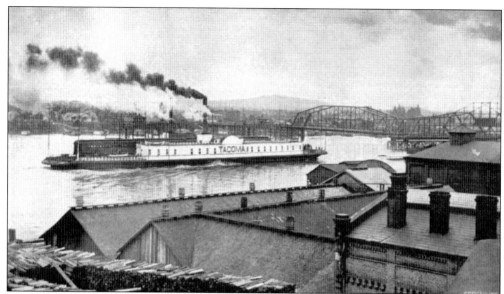

The Northern Pacific transfer boat *Tacoma* approaches the open, nearly completed Burnside Bridge in this photograph, taken during the 1894 flood. The *Tacoma* transferred passengers from Kalama, Washington, to the Jefferson Street docks in Portland. The bridge's swing span was 385 feet long and operated by steam power, with the machinery located in a steel room over the roadway. (Courtesy City of Portland Archives.)

A man poses with a specialized vessel in front of the partially opened Burnside Bridge and the original Steel Bridge in this undated photograph looking toward the northwest. The exhaust from the steam-powered swing span is visible along the left side of the swing span, above the fender system. (Courtesy Nelson family archive.)

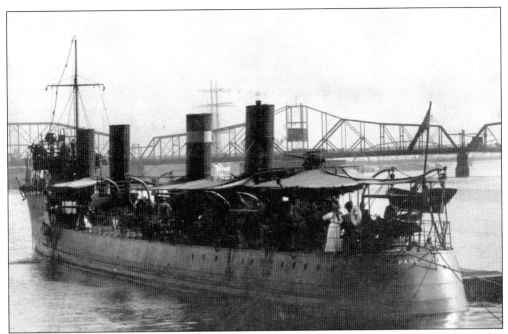

The U.S. Navy torpedo boat destroyer USS *Paul Jones* is tied north of the Burnside Bridge in this undated photograph. The *Paul Jones* was commissioned on July 19, 1902, in San Francisco with Lt. R. F. Gross in command. The *Paul Jones* was used to rescue 1,250 U.S. Marines and officers from the USS *Henderson*, burning north of Bermuda on July 2, 1918. (Courtesy author.)

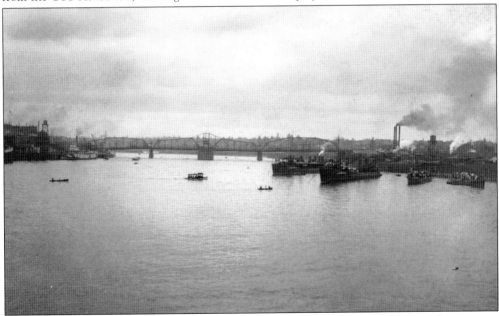

Several U.S. Navy ships similar to the torpedo-boat destroyer shown at the top of this page are anchored in Mediterranean moor configuration north of the Burnside Bridge in this undated photograph looking south. The bridge's 385-foot swing span was flanked by a 300-foot fixed truss on the east and a 240-foot fixed truss on the west, with a 32-foot-wide roadway and 7-foot sidewalks on each side. (Courtesy author.)

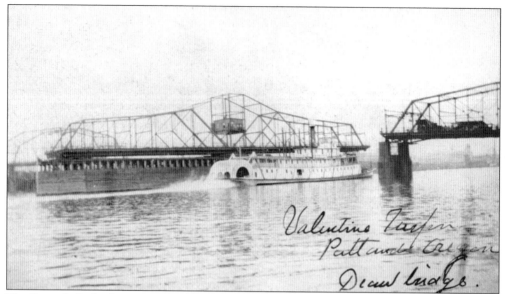

The Burnside Bridge has opened to allow a sternwheeler to pass through in this undated photograph. The bridge's first operator was Harry Stutsman, an engineer previously employed as a Portland fireman. F. G. Forbes was hired to help Stutsman operate the bridge, which opened an average of 27 times per day. (Courtesy Stephen Kenney Jr.)

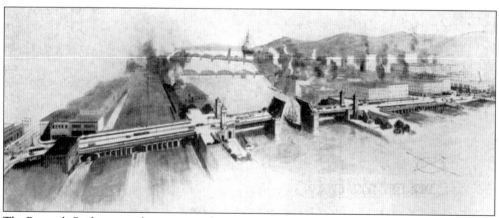

The Burnside Bridge opened an average of 10,000 times each year for river traffic, and the relatively slow speed of the swing-span drawbridge became unacceptable within a few decades. A proposal for a faster-operating, bascule-type drawbridge, similar to the final design of the new bridge, is shown in this 1921 artist's rendering. (Courtesy City of Portland Archives.)

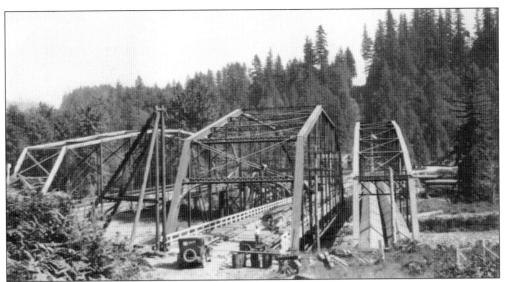

Several spans of the first Burnside Bridge were disassembled and relocated. A worker is standing on the lowest portal member during the rebuilding of the 300-foot east fixed span over the Sandy River at Dodge Park in this photograph. The span replaced the timber bridge to the left. The bridge at the right supported pipes that carried water from Bull Run Reservoir to Portland. (Courtesy ODOT.)

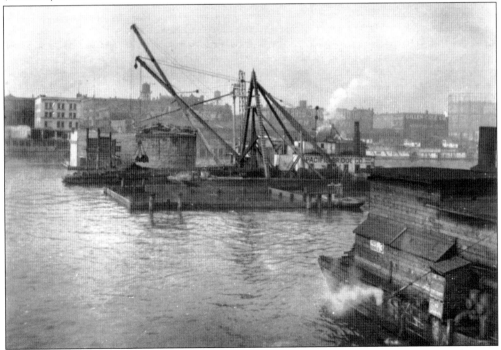

Pacific Bridge Company's dredge is excavating inside a timber cofferdam for one of the new Burnside Bridge's piers in this undated photograph. Pacific Bridge won the contract only after another contractor's higher bid was accepted, the Multnomah County Commissioners were arrested, indicted, and recalled, and new commissioners were appointed. (Courtesy Nelson Family Archive.)

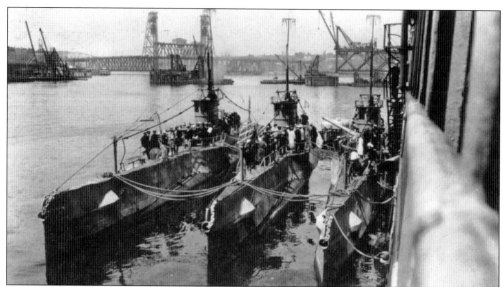

The east fixed truss of the new Burnside Bridge is under construction in this photograph featuring three U.S. Navy submarines. The fixed spans of the new bridge were designed by engineers Ira Hedrick and Robert Kremers of Portland. The design was continued with minor changes by consulting engineer Gustav Lindenthal of New York after Kremers was arrested on charges of bribery and collusion. (Courtesy Nelson family archive.)

The new Burnside Bridge is decorated in preparation for its May 28, 1926, opening festivities in this photograph. Also shown are the tracks and overhead wires for the electric streetcars, an operator's house, and the gates that close the roadway before the bridge opens to marine traffic. The $3 million drawbridge provides a 252-foot span over the navigation channel. (Courtesy City of Portland Archives.)

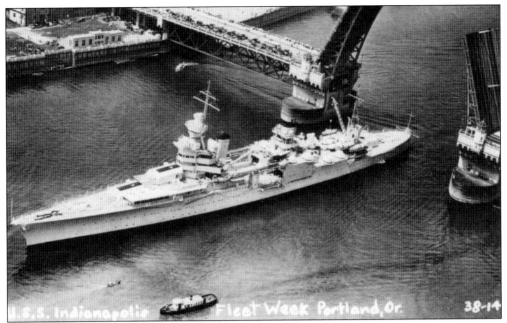

The USS *Indianapolis* passes through the Burnside Bridge in this undated postcard photograph. The bridge's double-leaf, bascule-type movable spans were designed by consulting engineer Joseph Strauss of Chicago, who went on to earn fame as the designer of the Golden Gate Bridge. The *Indianapolis* was commissioned in 1932, and sunk on July 28, 1945, just two weeks before the end of World War II. (Courtesy Stephen Kenney Jr.)

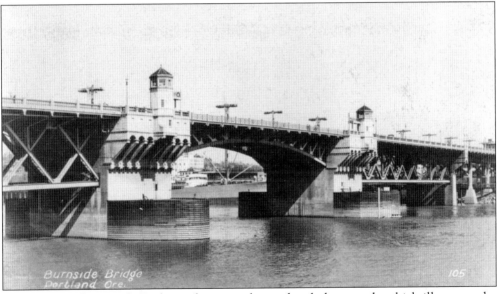

The completed Burnside Bridge is shown in this undated photograph, which illustrates the bridge's architectural features. Following the City Beautiful Movement, Multnomah County hired Houghtaling and Dougan Architects of Portland, on Hedrick and Kremers's recommendation. Architectural treatments include the concrete handrails with spindle-type balusters, the octagonal Italianate-style operator's houses, and the ornate brackets on the sides of the main piers. (Courtesy Stephen Kenney Jr.)

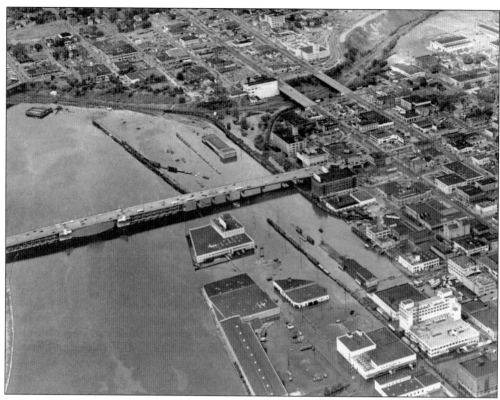

The notorious Vanport flood inundated the railroad facilities on the east bank of the Willamette River under the Burnside Bridge, as shown in this aerial photograph, dated June 14, 1948. The bridge's steel trusses were out of the water, and the bridge remained under traffic at the time of this photograph. (Courtesy City of Portland Archives.)

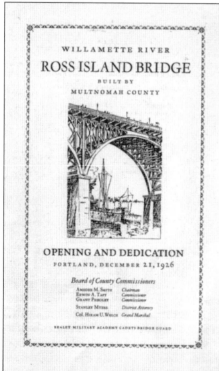

The Ross Island Bridge was part of a scandal-delayed Multnomah County project to build the Burnside, Ross Island, and Sellwood Bridges. The bridge was constructed to provide a needed Willamette River crossing near Ross Island, south of the Hawthorne Bridge, and it eventually carried the Mount Hood Highway. The county hired consulting engineer Gustav Lindenthal of New York to redesign the bridges after the scandal. (Courtesy Multnomah County.)

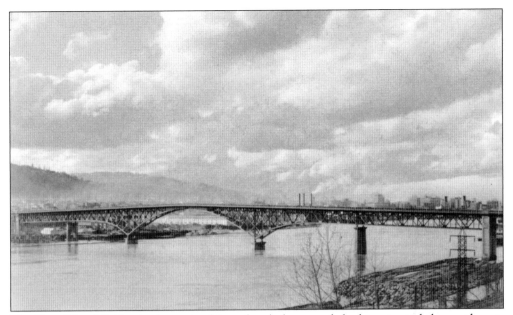

The Ross Island Bridge is shown in this undated photograph looking toward the northwest. The bridge's graceful main span is 535 feet long and provides approximately 123 feet of vertical clearance for navigation. The side spans were constructed on falsework, after which the main span was built from each side using steam-powered traveler derricks operating atop the trusses. (Courtesy Stephen Kenney Jr.)

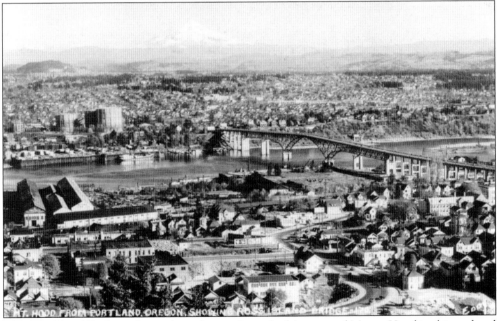

The Ross Island Bridge is shown from the northwest looking toward Mount Hood in this undated postcard photograph. One of Portland's more graceful bridges, the Ross Island Bridge cost $1.9 million, with Booth and Pomeroy erecting the steel spans, which were fabricated by American Bridge Company, and Lindstrom and Feigenson building the reinforced-concrete approach structures. (Courtesy author.)

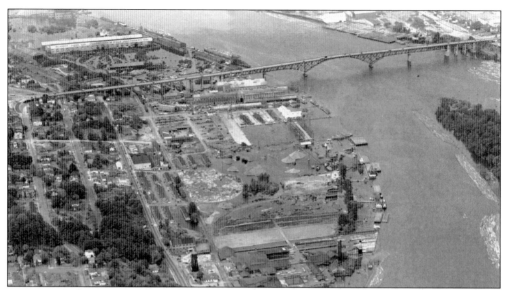

The Ross Island Bridge is shown above the waters of the Vanport flood in this photograph looking toward the north, dated June 17, 1948. This view shows the entire length of the 3,729-foot bridge, which consists of five steel-truss spans totaling 1,819 feet and reinforced-concrete approach spans totaling 1,910 feet, mostly on the west side. (Courtesy City of Portland Archives.)

A portion of the west approach to the Ross Island Bridge, at Front Avenue, is shown under construction in this 1948 photograph. Typical of Portland's large bridges, the connections of the Ross Island Bridge to the street system underwent a series of modifications to keep the bridge compatible with the changing street system. (Courtesy ODOT.)

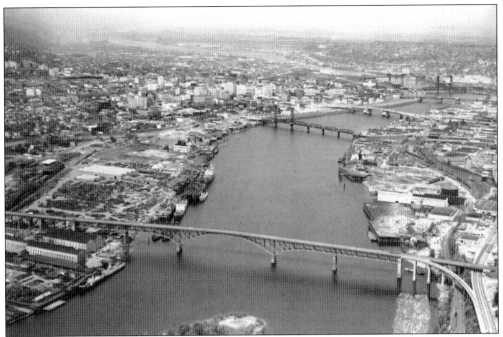

While the Ross Island Bridge appears to be a steel arch, it is actually a form of cantilever truss. At the center of the 535-foot main span, the diagonal members of the truss disappear into steel plates. The steel plates allow a thinner structure, which keeps the roadway as low as possible while providing the required vertical clearance for navigation. (Courtesy City of Portland Archives.)

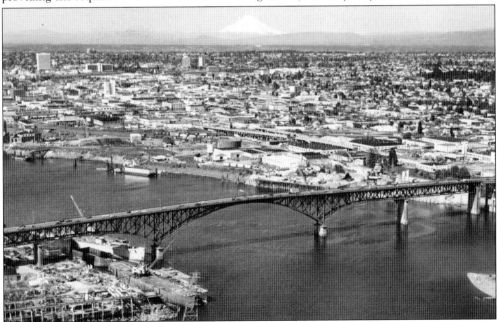

This aerial view looking northeast on May 11, 1973, shows the Ross Island Bridge with east Portland and southwest Washington's Mount St. Helens in the background. Also visible are Zidell Marine on the west bank of the river and Ross Island Sand and Gravel on the east bank. (Courtesy ODOT.)

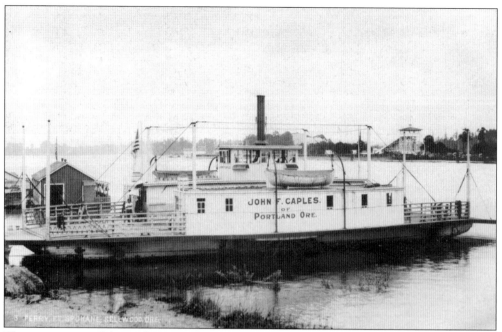

The steam-powered ferry *John F. Caples* carried an average of 582 vehicles and 482 pedestrians across the Willamette River to and from the Sellwood neighborhood each day. The Sellwood Bridge replaced this ferry as part of the Multnomah County project, which also built the new Burnside Bridge and Ross Island Bridge, and it was designed by consulting engineer Gustav Lindenthal of New York. (Courtesy Nelson family archive.)

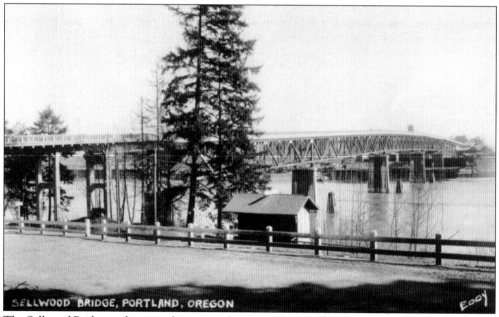

The Sellwood Bridge, as shown in this postcard view, was built for $541,637.19 by Gilpin Construction Company of Portland, with structural steel fabricated by Judson Manufacturing Company of San Francisco. The bridge was dedicated at 2:30 p.m. on December 15, 1925, followed by a banquet at the International Organization of Odd Fellows Hall. (Courtesy author.)

In 1960, repairs were made for extensive damage caused by settlement of the foundations for the west approach. The damage included the cracked concrete and tilted columns shown in this photograph, dated April 5, 1960. There is a long history of ground movement at the west approach, dating back to 1925. (Courtesy Multnomah County.)

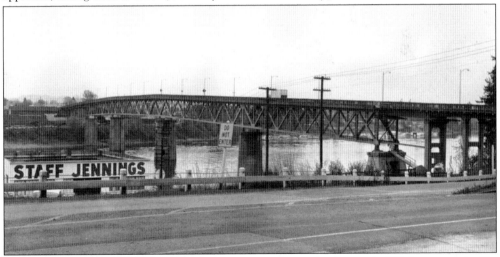

The Sellwood Bridge is a four-span, continuous steel-truss bridge, with 300-foot spans in the center of the river and 245-foot, 7-and-a-half-inch side spans, shown in this photograph, dated April 14, 1961. At each end of the continuous truss-steel-plate girders from the 1894 Burnside Bridge were reused, and the remaining approach spans were constructed of reinforced concrete. (Courtesy Multnomah County.)

The Sellwood Bridge's Gothic arch–style handrail is illustrated in this roadway view, dated August 5, 1965. The handrail design was changed from a steel-pipe rail to the Gothic-style, reinforced-concrete design. The bridge provides two lanes on a 24-foot-wide roadway with a 6-foot-9-inch sidewalk on the north side. (Courtesy Multnomah County.)

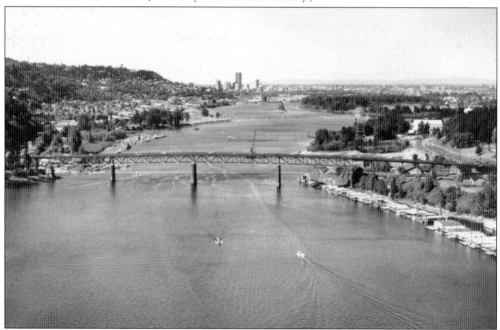

The Sellwood Bridge is the farthest upriver of Portland's Willamette River bridges. This aerial view from May 11, 1973, shows the bridge with the downtown Portland skyline several miles to the north. There is approximately 75 feet of vertical clearance for the barge-mounted crane just beyond the bridge, which almost appears to be atop the bridge. (Courtesy ODOT.)

Four

BROADWAY AND NORTHERN PACIFIC RAILWAY BRIDGES

In September 1905, the Northern Pacific Railways hired consulting engineer Ralph Modjeski, shown in this photograph, of Chicago to design three bridges to connect Vancouver, Washington, with Portland. An office was opened in Vancouver in November 1905, plans were submitted to the U.S. War Department in January 1906, and plans were approved in February. Work began on the Columbia River and Oregon Slough Railroad Bridges immediately, while negotiations continued with the Port of Portland regarding the Willamette River Railroad Bridge. Before approval was granted, the swing span was enlarged until it was the largest swing span in the world at the time, the vertical clearance over the water was increased to a level 16.62 feet higher than the Columbia River and Oregon Slough Railroad Bridges, and all three bridges were to be made available to competing railroads. The Port of Portland approved the bridge in April 1906, and the U.S. War Department approved the bridge in June 1906. Construction work on the Willamette River Railroad Bridge began in August 1906. (Courtesy Modjeski and Masters, Incorporated.)

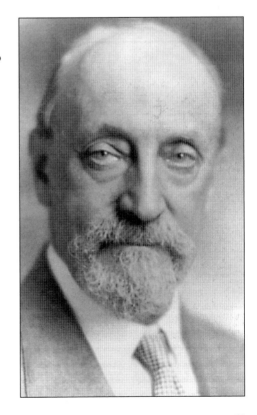

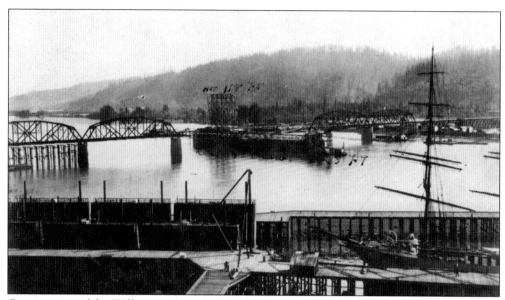

Construction of the Willamette River Railroad Bridge is under way in this undated photograph. Falsework is still present under one of the fixed spans at left, and the record-setting 524-foot, 2-inch swing span is beginning to take shape atop the fender system. In the foreground is the Port of Portland's drydock facility. (Courtesy Nelson family archive.)

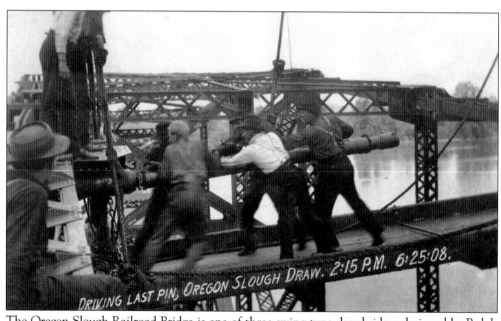

DRIVING LAST PIN, OREGON SLOUGH DRAW. 2:15 P.M. 6:25:08.

The Oregon Slough Railroad Bridge is one of three swing-type drawbridges designed by Ralph Modjeski for the Northern Pacific Railway. The swing span is a pin-connected truss, with the upper members connected by large steel pins. This action shot, taken June 25, 1908, shows workmen on a wooden platform ramming the last pin into place. The ram is supported by a rope from a crane above. (Courtesy Virgil Reynolds.)

This riveting crew probably worked on the Oregon Slough or Columbia River Railroad Bridges. The rivets were heated in the blacksmith-type forge that is partly visible behind the crew and installed using tongs. While still hot, the rivet head was "bucked" by one workman while another (in this case, the second man from the left) used a rivet gun to form a head on the opposite end of the rivet. (Courtesy Virgil Reynolds.)

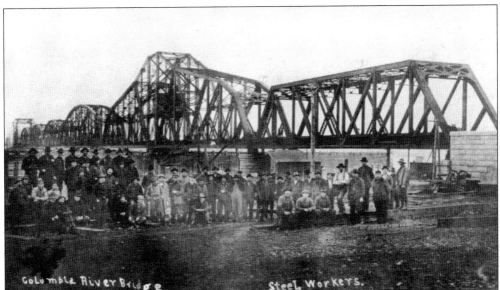

The steel workers in this photograph at the Vancouver end of the Columbia River Railroad Bridge erected the bridge using the traveler visible at far left. There are several more 265-foot fixed spans to complete before the traveler reaches Hayden Island. The bridge has a 467-foot swing span, numerous 265-foot fixed spans, and a single fixed span to the right. (Courtesy Stephen Kenney Jr.)

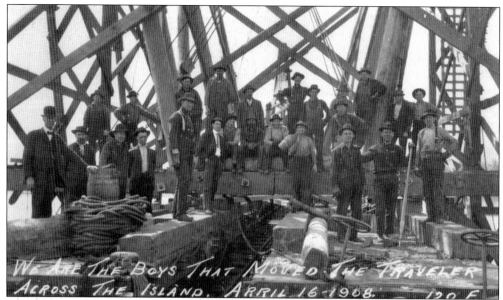

The Columbia River and Oregon Slough Railroad Bridges are separated by Hayden Island. The traveler in this photograph, dated April 16, 1908, was moved across Hayden Island by this crew. The traveler was a mobile timber tower used to erect the steel trusses; it would move across the river on temporary pilings as the bridge was built. (Courtesy Virgil Reynolds.)

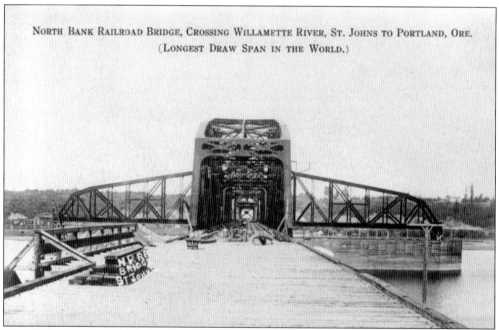

The Willamette River Railroad Bridge at St. Johns is shown open to marine traffic during track laying in this 1908 postcard view. The swing span had a record 524-foot, 2-inch overall length and 4.6 million-pound weight. Byron B. Carter was appointed by Ralph Modjeski as the mechanical engineer for the Columbia River, Oregon Slough, and Willamette River railroad drawbridges. (Courtesy City of Portland Archives.)

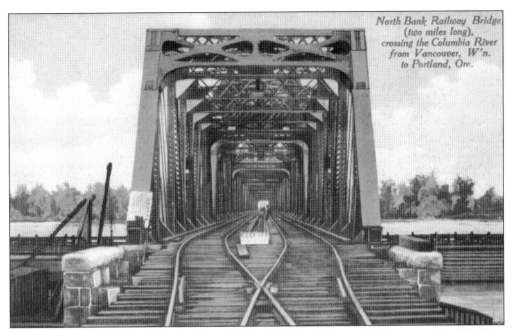

The Vancouver end of the Columbia River Railroad Bridge is shown in this postcard view looking through the bridge toward Hayden Island. The Columbia River, Oregon Slough, and Willamette River Railroad Bridges were built with two sets of tracks, at least partly a result of Port of Portland's demands that the bridges be available for the use of competing railroads. (Courtesy author.)

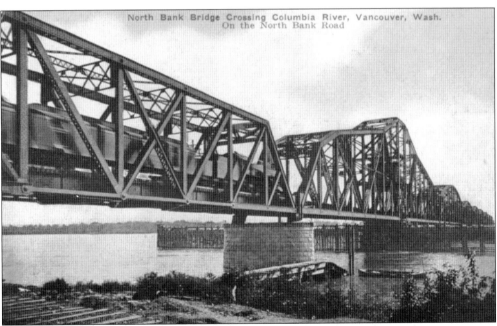

A train is crossing the Columbia River Railroad Bridge in this postcard view looking toward the southeast from the Vancouver side of the river. Early postcards and publications often referred to the Columbia River, Oregon Slough, and Willamette River Railroad Bridges as being "on the North Bank Road." (Courtesy author.)

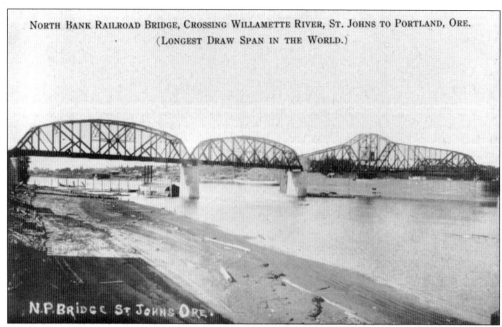

The Willamette River Railroad Bridge, with its record setting 524-foot, two-inch swing span, is shown in this postcard view opened for marine traffic. The bridge's designer, Ralph Modjeski, was born in Krakow, Poland, in 1861. After attending engineering school in France, Modjeski gained employment with bridge builder George Morison in 1885, and seven years later started his own consulting firm, now known as Modjeski and Masters, Inc. (Courtesy author.)

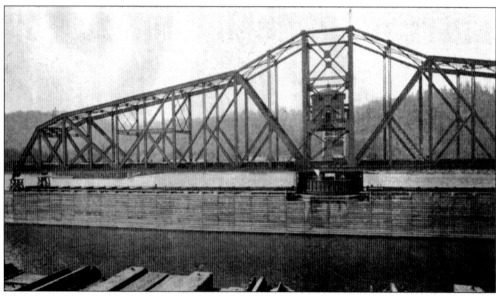

The swing span of the Willamette River Railroad Bridge is shown open for marine traffic in this photograph, taken from the adjacent fixed span. The drum visible beneath the span is 42 feet in diameter, supporting a total weight of approximately 4.6 million pounds, of which about 400,000 was machinery. (Courtesy Multnomah County Library.)

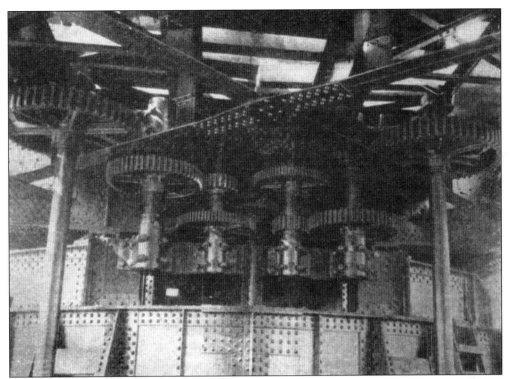

The drum and the speed-reducing gearing that connects the electric drive motors to the pinion gears that mesh with a stationary rack gear on top of the pier are shown in this view on the Willamette River Railroad Bridge. The diagonal members overhead are braces that give the swing span lateral rigidity. (Courtesy Multnomah County Library.)

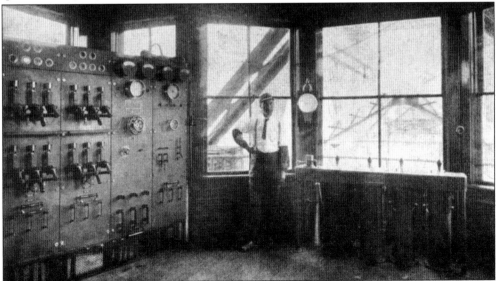

The bridge operator and the interior of the bridge operator's house on the Willamette River Railroad Bridge are shown in this view. The operator had large windows to see railway traffic and marine traffic, and some large electrical controls. Specifications required the bridge to be capable of opening in less than three minutes. (Courtesy Multnomah County Library.)

The Willamette River Railroad Bridge's backup generator set is shown here. The power was provided by a 165-horsepower, four-cylinder gasoline engine, while the Columbia River Railroad Bridge had a 125-horsepower, three-cylinder gasoline engine. In addition to the backup generators, there were auxiliary motors for use if the primary electric motors failed. (Courtesy Multnomah County Library.)

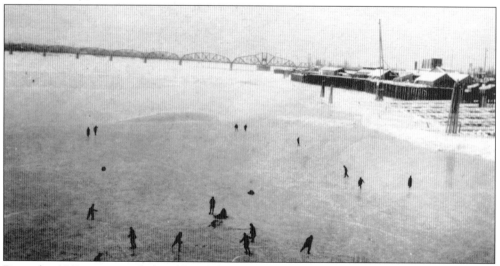

December 1919 was particularly cold, and the people in this photograph, taken from the Interstate Bridge looking toward the Columbia River Railroad Bridge, took advantage of the weather to ice skate on the Columbia River. The ice was so thick some people were driving cars on it. (Courtesy Nelson family archive.)

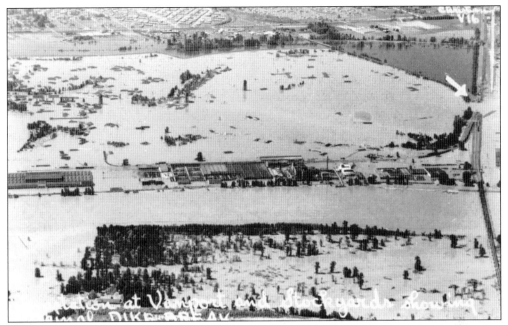

The original dike break during the 1948 Vanport flood is indicated by the arrow in this view looking south. The Oregon Slough Railroad Bridge is visible at the lower right, with the swing span near its south end. The stockyards are along the south bank of the slough, and the doomed Vanport community, once home to wartime shipyard workers, is to the south and east. (Courtesy author.)

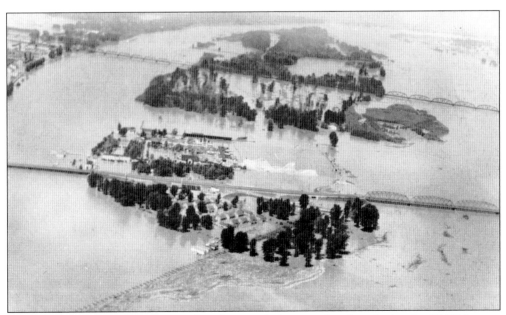

Much of Hayden Island is submerged in this aerial photograph, taken during the 1948 Vanport flood. The Columbia River Railroad Bridge is near the top right, the Oregon Slough Railroad Bridge is at the top left, the Interstate Bridge is near the lower right, and the bridge carrying Pacific Highway over Oregon Slough is at the center left. (Courtesy author.)

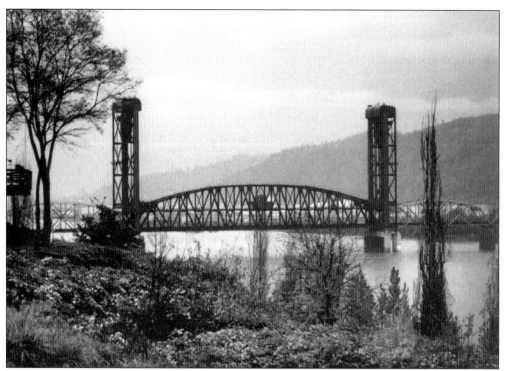

In 1989, the Willamette River Railroad Bridge's owner, Burlington Northern Railroad, removed the swing span and its center pier and installed a single vertical lift span and towers. The transformation from swing-type to vertical-lift drawbridge was made within a 72-hour period. The vertical-lift span, shown here on November 10, 2006, improved clearance available for navigation. Before the retrofit, numerous vessels collided with the bridge. (Courtesy author.)

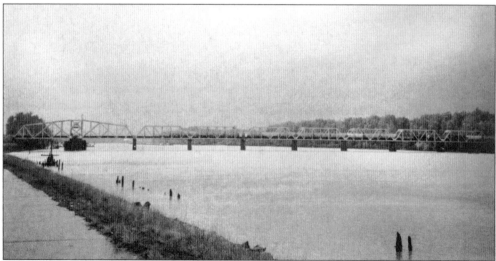

A train crosses the Oregon Slough Railroad Bridge in this photograph, taken November 10, 2006. The swing span and its navigation channel are located at the south bank of the slough, with seven fixed-truss spans to the north. The Oregon Slough, Columbia River, and Willamette River Railroad Bridges together connect Vancouver with Portland with a total of 3 movable spans and 21 fixed-truss spans. (Courtesy author.)

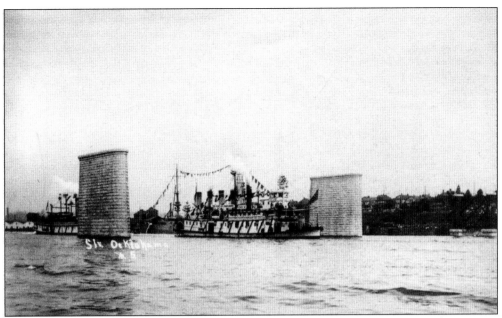

A sternwheeler passes the main piers for the Broadway Bridge, built to carry Broadway Street across the Willamette River. The main piers are faced with granite and are also topped with granite to ensure more even distribution of loading at the top. To the right, a shoreward pier is nearly complete, consisting of a pair of concrete-filled, 12-foot-diameter steel cylinders braced together. (Courtesy Stephen Kenney Jr.)

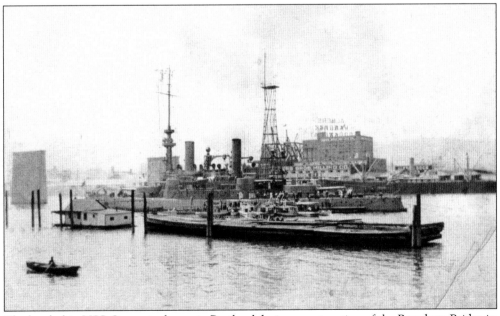

The battleship USS *Oregon* is shown in Portland during construction of the Broadway Bridge in this undated photograph. The *Oregon* was laid down November 19, 1891, by Union Iron Works in San Francisco, California, and commissioned on July 15, 1896, with Capt. Henry L. Howison in command. (Courtesy Nelson family archive.)

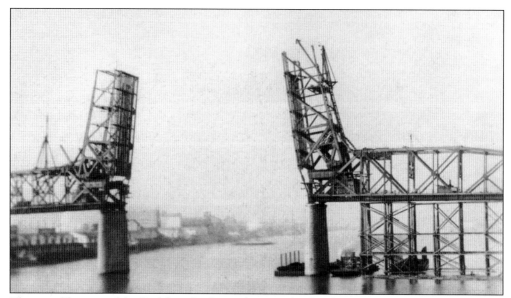

The movable spans of the Broadway Bridge are being erected in the open position to accommodate marine traffic in this photograph. A crane is visible within the structural steel on the right bascule leaf, and falsework that supported the adjacent fixed span during construction is still in place. The Rall bascule spans were designed by Strobel Engineering of Chicago. (Courtesy Stephen Kenney Jr.)

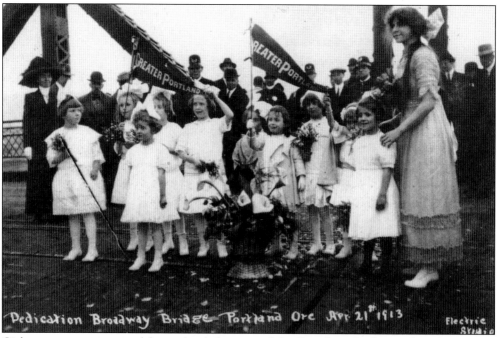

Girls wave pennants to celebrate the dedication of the Broadway Bridge in this photograph, dated April 21, 1913. The $1.6 million bridge provided four traffic lanes and two 11-foot sidewalks within a 70-foot overall width. The bridge was designed by consulting engineer Ralph Modjeski of Chicago. (Courtesy Stephen Kenney Jr.)

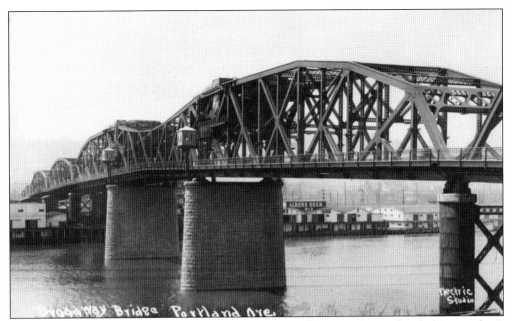

The completed Broadway Bridge, in closed position, is shown in this undated photograph. A bridge operator's house is located above each of the granite-faced main piers. The Broadway Bridge's structural steel was fabricated and erected by the Pennsylvania Steel Company of Steelton, Pennsylvania. The 3,000-foot bridge provides a 278-foot, double-leaf bascule span over the navigation channel. (Courtesy Stephen Kenney Jr.)

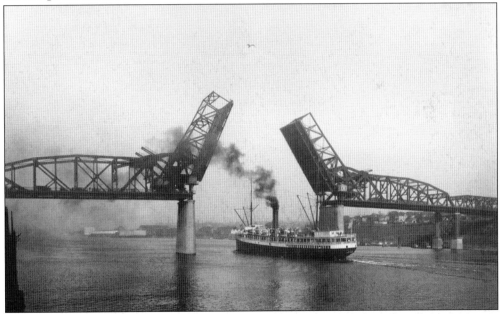

The Broadway Bridge is opened for the Oregon-Washington Railroad and Navigation Company's steamer *Alaskan* in this photograph. The bridge is a rare example of a Rall bascule-type drawbridge. The bascule leaf does not hinge about a fixed point; instead the hinge point rolls on a track, retracting as the leaf lifts. The leaf is actuated by a strut that is geared to the drive motors. (Courtesy ODOT.)

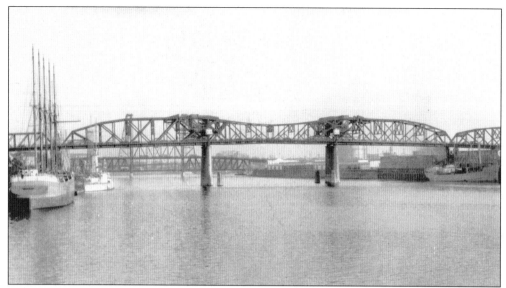

The main spans of the Broadway Bridge and ships in Portland's harbor are shown with the Steel Bridge in the background in this undated photograph. The elaborate Rall mechanism and counterweights are overhead within the fixed trusses near the main piers. Each bascule leaf was powered by two 75-horsepower General Electric motors. (Courtesy author.)

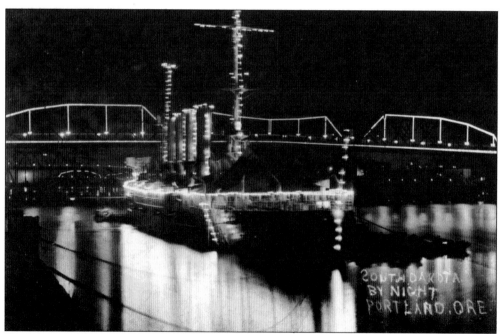

The outlines of the Broadway Bridge are lighted along with the armored cruiser USS *South Dakota* in this undated view. The *South Dakota* was launched on July 21, 1904, by Union Iron Works at San Francisco and was commissioned on January 27, 1908, with Capt. James T. Smith in command. (Courtesy Stephen Kenney Jr.)

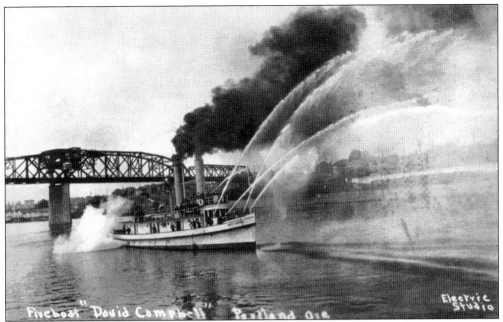

Portland's steam-powered fireboat *David Campbell* demonstrates some of its capabilities in front of the Broadway Bridge in this undated photograph. Fireboats are necessary to properly protect Portland's extensive harbor and waterfront areas, and may have been useful to protect the Steel Bridge, which suffered at least one fire in its timber upper deck. (Courtesy Stephen Kenney Jr.)

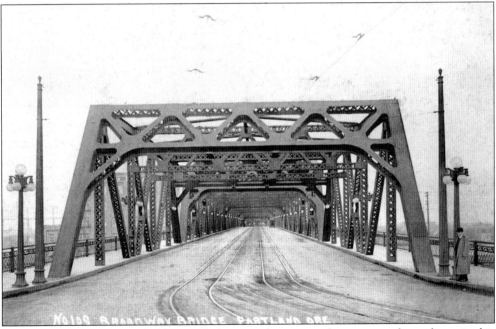

The Broadway Bridge provided four traffic lanes, with two sets of streetcar tracks, as shown in this undated photograph. Installation of the streetcar tracks was delayed by a change in the required gauge of track, but once completed, the streetcar route from northeast to northwest Portland was much shorter. (Courtesy Stephen Kenney Jr.)

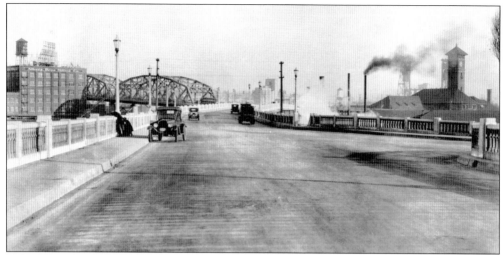

A 1926 or 1927 Ford Model T roadster pickup and other early vehicles travel on the completed Lovejoy Viaduct in this photograph, dated December 20, 1928. The viaduct, designed by consulting engineer Gustav Lindenthal of New York, improved connections to the west end of the Broadway Bridge by removing one truss span and building the viaduct during a six-month closure to traffic. (Courtesy City of Portland Archives.)

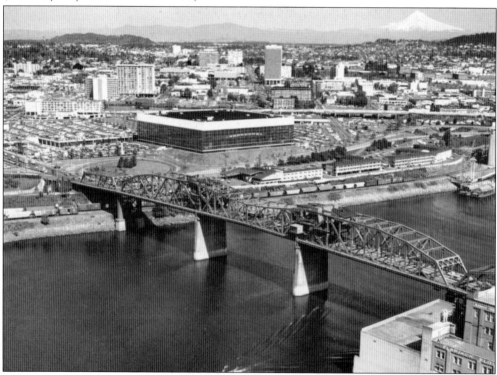

The elaborate mechanism and counterweights required to operate the Broadway Bridge's rare double-leaf, Rall bascule-type drawbridge are shown in this aerial photograph looking southeast on May 11, 1973. Also visible is the operator's house above the pier on the west side of the main channel, a tug, Albers Mills on the west bank of the river, and Mount Hood in the distance. (Courtesy ODOT.)

Five

INTERSTATE BRIDGES

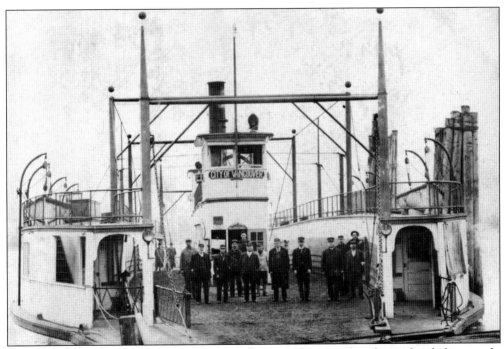

The steam-powered ferry *City of Vancouver* is shown with its crew in this undated photograph. The ferry crossed the Columbia River between the foot of Washington Street in Vancouver and Hayden Island in Oregon, at the site where the future Interstate Bridge would carry Pacific Highway across the river. A long wooden trestle across Hayden Island and Oregon Slough connected the Oregon ferry landing to higher ground, and a trestle carried Portland streetcars to the ferry landing. By the early 20th century, the ferry became inadequate, and Multnomah County, Oregon, and Clark County, Washington, worked together to issue bonds and build a toll bridge. The Interstate Bridge was designed by consulting engineers Waddell and Harrington of Kansas City, Missouri, who broke up their partnership in 1915, leaving Harrington's new firm, Harrington, Howard, and Ash, to oversee construction of the bridge. The piers for the bridge were constructed by Pacific Bridge Company of Portland, and the steel-truss spans were fabricated by American Bridge Division of United States Steel Company and erected by Porter Brothers of Portland. (Courtesy Stephen Kenney Jr.)

The barge-mounted pile driver used to sink the foundation piles for the piers of the Interstate Bridge is shown here. The barge is equipped with two hoisting engines, two pumps, and an 800-horsepower boiler. The leads are 122 feet above the water and 22 feet from the front of the barge. (Courtesy Multnomah County Library.)

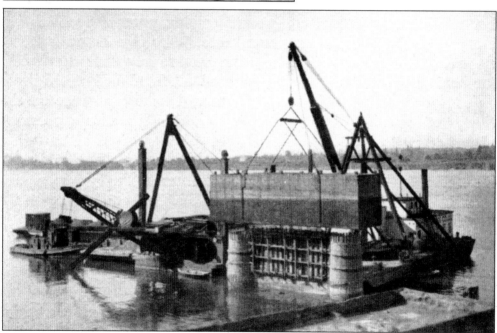

A barge-mounted, steam-powered hoisting rig is removing a wooden cofferdam from one of the Interstate Bridge piers in this photograph. The 50-ton, 17-foot-high wooden cofferdam is 16 feet by 57 feet and was reused throughout the project. The piers were built by the Pacific Bridge Company of Portland. (Courtesy Multnomah County Library.)

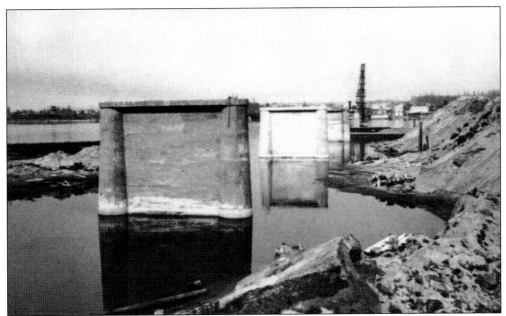

Some of the piers for the Interstate Bridge are complete in this undated photograph looking toward the north. Construction of the piers consumed 21,629 cubic yards of concrete, 99,960 pounds of reinforcing steel, 78,826 lineal feet of permanent piling, 19,672 lineal feet of temporary piling, 298,600 board feet of timber, and 10,604 cubic yards of riprap. (Courtesy Nelson Family Archive.)

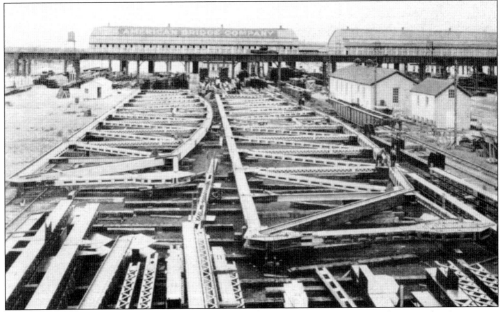

The truss panels for the movable span of the Interstate Bridge are shown here at the American Bridge Company's shop in Gary, Illinois. All of the trusses were preassembled, holes for field rivets were reamed in proper position, and the members were match-marked for field assembly. Only six rivet holes out of 17,000 field rivets required correction in the first truss span. (Courtesy Multnomah County Library.)

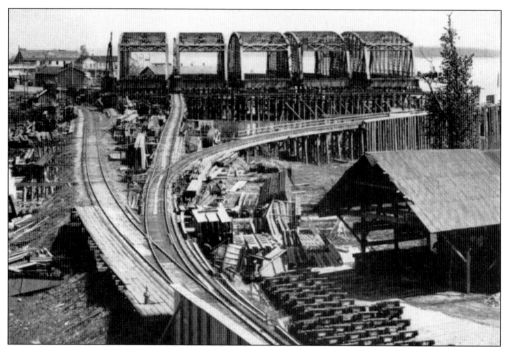

Five of the fixed span trusses, steel storage, and industrial railway tracks are shown at the contractor's erection yard on the Vancouver shore of the Columbia River in this photograph. The trusses were erected at left, and when they were completed, they were moved along the launching ways toward the river. The truss spans were erected by Porter Brothers of Portland. (Courtesy Multnomah County Library.)

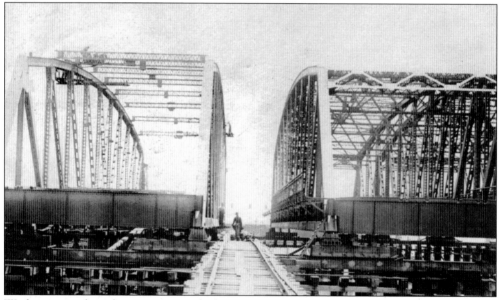

Workers are working from temporary platforms to erect the truss shown at the left in this undated photograph taken at the contractor's Vancouver yard. The substantial timber supports carrying the trusses and the launching ways are visible, along with some of the industrial railway tracks. (Courtesy Stephen Kenney Jr.)

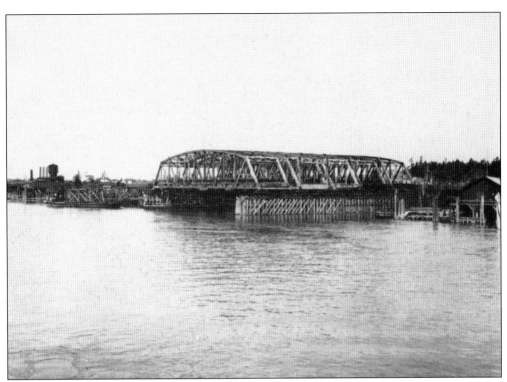

The truss-launching ways and a barge are here. The ways were built to allow four barges, each ballasted with water, to fit underneath the truss. With the barges under the truss, timber falsework was built to carry the truss above the elevation of its piers, and the ballast was pumped out of the barges, causing them to pick up the truss. (Courtesy Multnomah County Library.)

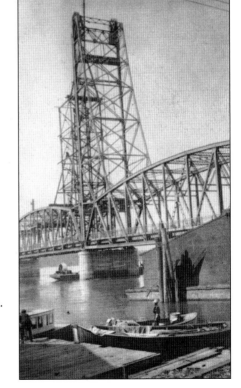

One of the Interstate Bridge's towers is nearly complete, and two large sheaves have been placed at the top of the tower in this undated photograph. The movable span is in place and is supporting the temporary tower and the boom that lifted the sheaves into place. The sheaves carry the lifting ropes over the top of the towers. (Courtesy Stephen Kenney Jr.)

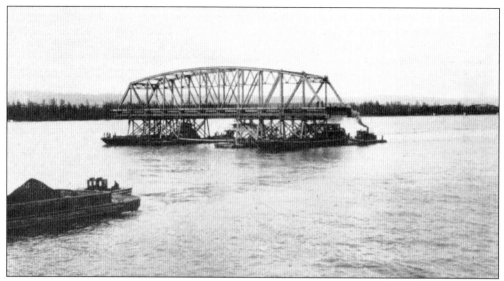

One of the 275-foot-long, 500-ton, steel-truss spans is being carried from the launching ways to the bridge by four barges in this photograph. The contractor used two steamboats, along with tugs, to move each barge-mounted truss. The timber falsework that carries the truss high enough to fit on its piers is clearly visible. (Courtesy Multnomah County Library.)

The machinery that operates the lift span is shown here, preassembled in the shop where it was built. Preassembly was required to ensure accurate fit-up of the parts on the bridge. Each of the four drums drives the 16 two-inch-diameter wire ropes that connect each corner of the lift span to the counterweights. (Courtesy Multnomah County Library.)

Both towers are complete, with their operating ropes and counterweights in place, in this undated photograph. Construction of the bridge started on the north bank of the Columbia River and proceeded toward the south. This would have allowed the lift span to be completed and working or simply to be left up before the river was blocked by the remaining trusses. (Courtesy Stephen Kenney Jr.)

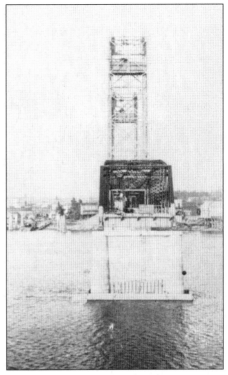

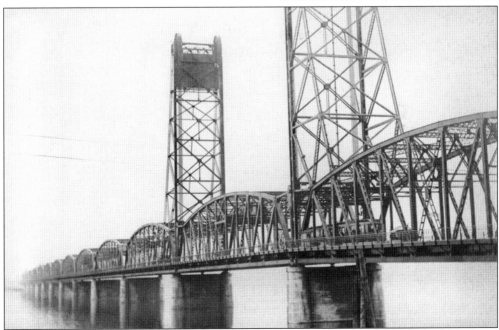

A streetcar uses the new Interstate Bridge in this undated photograph taken from the Vancouver shore. On September 1, 1916, the Portland Railway, Light, and Power Company was granted a franchise by Multnomah County to use the streetcar rails on the bridge; however, the City of Vancouver did not grant a franchise to place rails there until January 1917. (Courtesy Stephen Kenney Jr.)

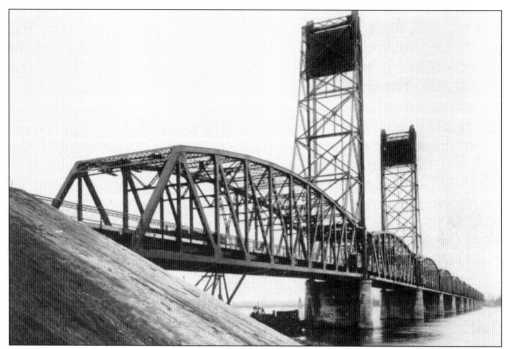

The new Interstate Bridge is shown from the north bank of the Columbia River in this photograph looking toward the southeast. The movable span, between the towers, weighs approximately 1,200 tons, and each counterweight weighs approximately 600 tons. The movable span can be lifted to 136 feet above the top of the piers, and the towers reach 190 feet above the roadway. (Courtesy Multnomah County Library.)

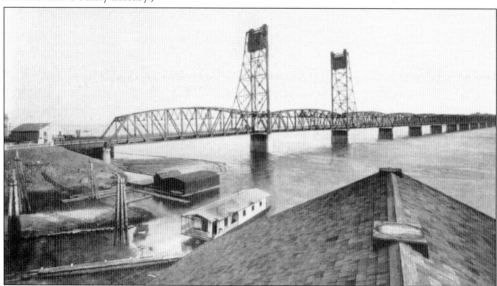

The north end of the completed Interstate Bridge and the nearby ferry landing are shown in this view looking toward the southeast. The bridge was built during 1915 and 1916 at a cost of approximately $1.7 million, and it opened to traffic in February 1917. The machinery that operates the movable span was installed in the house in the top part of the span. (Courtesy Multnomah County Library.)

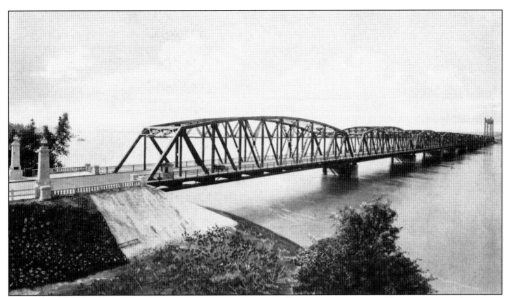

The south end of the completed 3,531-foot, 6-inch Interstate Bridge and the ornate pylons and handrail at the entrance to the bridge are shown in this photograph, taken from upstream on Hayden Island during high water. The Oregon landing for the Portland-Vancouver ferry was a short distance upstream from the bridge. (Courtesy Multnomah County Library.)

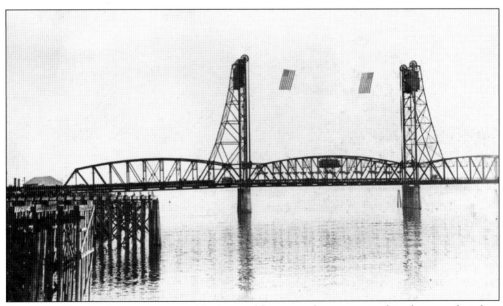

American flags fly from a rope or cable fastened between the towers in this photograph, taken from the west on February 14, 1917, the day the bridge officially opened to traffic. At left, the contractor's truss-launching ways are still visible. The cost of the bridge was approximately $1.7 million. (Courtesy Stephen Kenney Jr.)

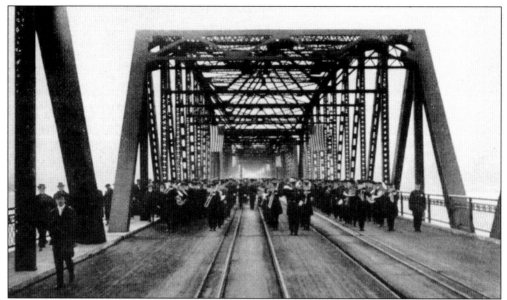

A parade led by the marching band and U.S. troops, shown in this photograph, taken on February 14, 1917, crossed the Interstate Bridge to officially open the bridge for public traffic. The two sets of streetcar tracks are clearly visible in the center of the bridge. Each track had three rails so that it could carry two different streetcar gauges. (Courtesy Multnomah County Library.)

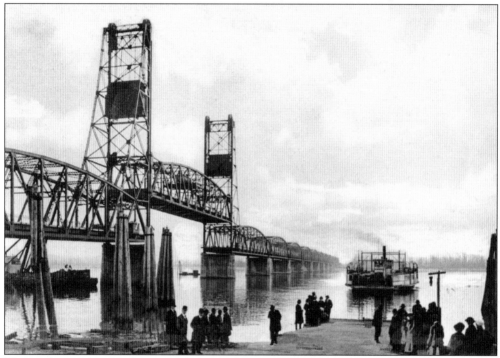

The newly completed Interstate Bridge is partly open for the vessel at left as the *City of Vancouver* passes in this 1917 photograph. The steel-truss spans of the 3,531-foot bridge cost $891,000 to build, and at 5¢ per automobile, it generated $300 per day in tolls in 1917, which increased to $300,000 per year by 1921. (Courtesy ODOT.)

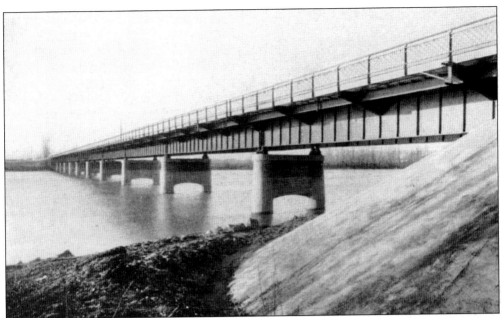

The Oregon Slough Bridge, the 1,140-foot steel-plate-girder bridge in this photograph looking southwest from Hayden Island, was built as part of the Interstate Bridge project in 1915 and 1916. When the cost of the Oregon Slough Bridge, the Columbia Slough Bridge, embankment and pavement across Hayden Island, right-of-way acquisition, and engineering fees are included, the total cost of the project comes to about $1.7 million. (Courtesy Multnomah County Library.)

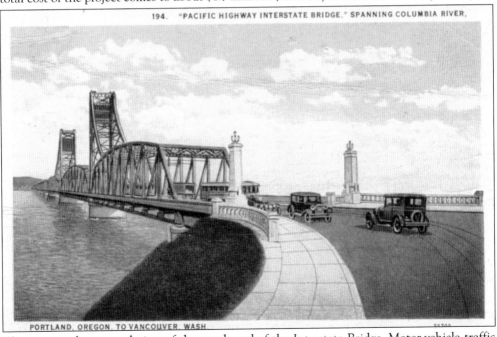

This is an early postcard view of the north end of the Interstate Bridge. Motor-vehicle traffic shared the bridge with streetcars, as shown here, and pedestrians used the sidewalk along the east side of the bridge. The ornate pylons and curved handrails created a pleasing entrance to the bridge. (Courtesy Julie Albright.)

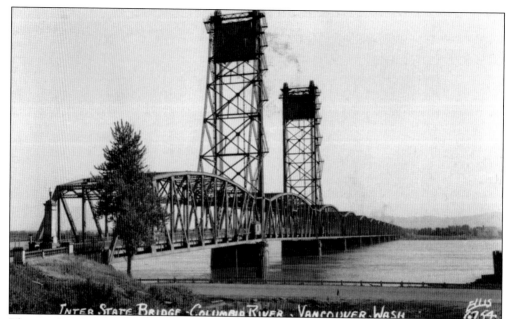

The new Interstate Bridge spans high water in this undated postcard view. The toll to cross the bridge was 5¢ for a horse and rider and 5¢ for a driver and vehicle, which gave the traveler a safer and much more convenient way to cross. (Courtesy Stephen Kenney Jr.)

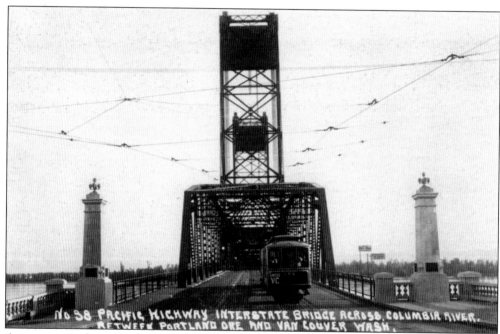

A streetcar is shown with a web of electric lines overhead on the Interstate Bridge in this undated view. The ornate pylons at the end of the bridge, the concrete handrail on the wider pedestrian plaza, and the graceful steel handrail on the trusses are also shown. (Courtesy Stephen Kenney Jr.)

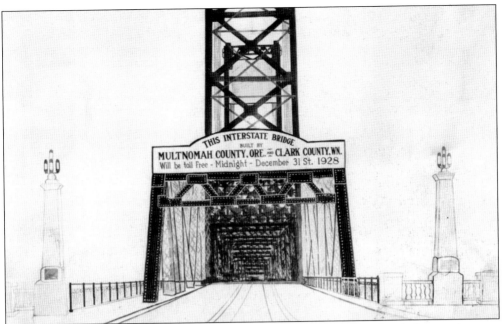

The ending of tolls on the Interstate Bridge was a major occasion. This sketch shows a sign over the bridge's portals declaring that the bridge will be toll-free on midnight, December 31, 1928. The sign also gives credit to Multnomah County, Oregon, and Clark County, Washington, for building the bridge. (Courtesy Stephen Kenney Jr.)

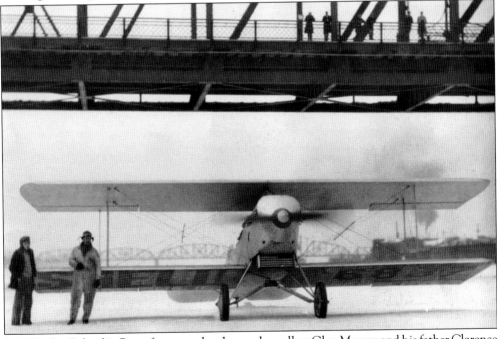

In 1930, the Columbia River froze over hard enough to allow Glen Murray and his father Clarence Murray to land Glen's American Eagle biplane on the ice. This photograph shows them with the American Eagle below the east side of the Interstate Bridge with the Columbia River railroad bridge in the background. (Courtesy Dusty Schmidt.)

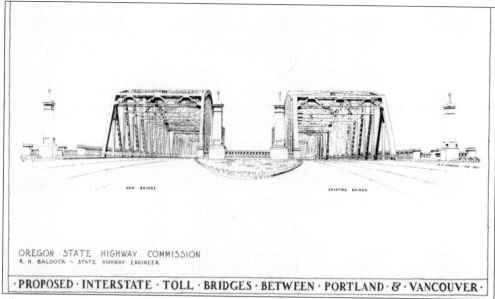

This artist's rendition of the south end of original Interstate Bridge with a new twin structure was created by Oregon State Highway Department graphic artist Harold L. Spooner in August 1953. When built, the twin structure presented a similar general appearance and shape as the original bridge, but there are many subtle differences due to changes in structural-steel-design practices. (Courtesy ODOT.)

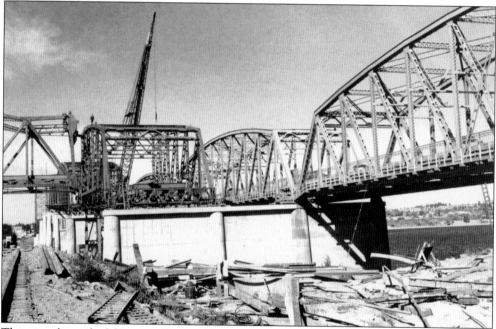

This view shows the lift span under construction and a worker walking on the upper member of a truss near the south end of the twin Interstate Bridge. The spans to the north are climbing toward the alternate shipping channel, which allows many vessels to pass without opening the bridge. After the twin bridge was completed, the original bridge was modified to match it. (Courtesy Oregon State Archives.)

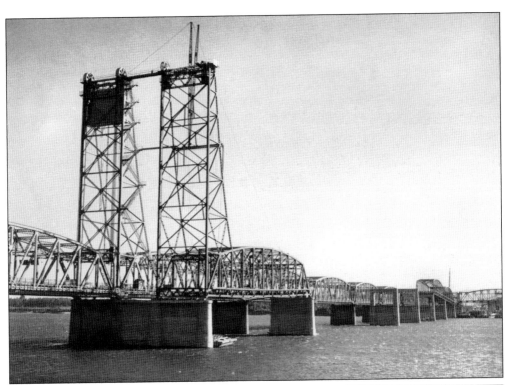

The twin Interstate Bridge is under construction in this view looking toward the southeast. Construction of the twin bridge was estimated to cost $6.7 million and modifications of the original bridge were estimated to cost $3 million. The twin bridge was opened for traffic on June 30, 1958, and the original bridge was closed for modifications. (Courtesy Oregon State Archives.)

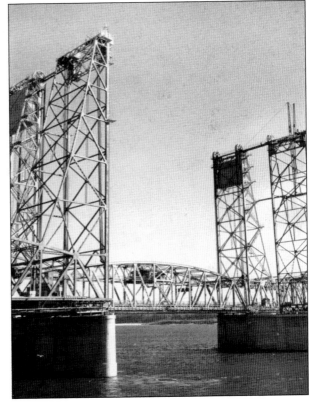

The towers of the twin Interstate Bridge are nearing completion in this view looking toward the southeast. The double-boom crane used to install the large sheaves is mounted on the south tower, and a worker is visible on the temporary platform near the sheave's final location atop the tower. The sheaves carry the lifting wire ropes over the top of the towers to the counterweights. (Courtesy Oregon State Archives.)

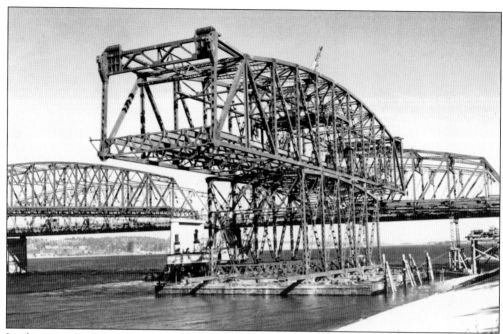

In this view looking toward the east, the lift span for the twin Interstate Bridge is mounted on a barge and is ready to be moved by the tug to its place between the towers. The lift span is supported atop a section of another truss and appears complete, except for its concrete deck, sidewalk, painting, and operating machinery. (Courtesy Oregon State Archives.)

Ice on the Columbia River at Portland is unusual, especially in the quantities visible in this photograph, dated January 9, 1979. This view shows the 1958 modifications, which included adding an alternate shipping channel, raising the bridge, and adding an extra long span to allow more vessels to pass from the southeast without opening the bridge. (Courtesy City of Portland Archives.)

Six

ST. JOHNS BRIDGE

The St. Johns Bridge, Portland's only suspension bridge, was designed by consulting engineers Holton D. Robinson, Ph.D., and David B. Steinman, Ph.D., of New York. The St. Johns Bridge connected the Linnton and St. Johns communities in north Portland. Steinman, shown here with his masterpiece, the massive Mackinac Straits Bridge in Michigan, was the country's most eminent suspension bridge engineer. Steinman was born in New York in 1886 and was reportedly a mathematical prodigy. He attended evening high school, earned a doctorate from Columbia University in 1911, and began teaching at the University of Idaho. He left teaching to become an assistant to consulting engineer Gustav Lindenthal during design of the 1917 Hell Gate Bridge over the East River in New York. Thus began Steinman's outstanding career in bridge design, which produced over 400 bridges. Steinman once said of the St. Johns Bridge that it was his favorite because "I put more of myself into that bridge than any other bridge." (© State of Michigan, 1957.)

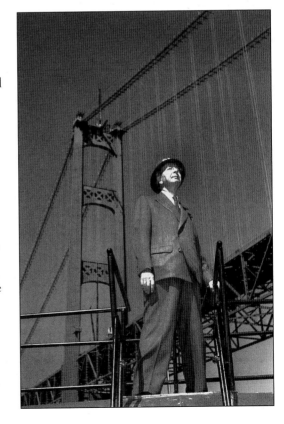

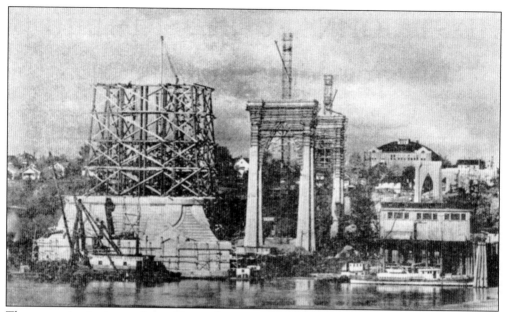

The east main pier is complete with wooden tower scaffolding partly erected beside it, and tower cranes are working on the piers to the east in this view looking toward the northeast. The main piers were built by Pacific Bridge Company of Portland, and the east approach piers were built by Gilpin Construction Company of Portland. (Courtesy Multnomah County Library.)

A complete tower leg for the St. Johns Bridge is shown in an assembly bay at Wallace Bridge and Structural Steel Company of Seattle in this undated view. The bracing of the towers is arranged to provide a Gothic style–arch appearance, matching the arched openings in the viaduct piers. (Courtesy author.)

The nearly complete east main tower of the St. Johns Bridge is shown with a massive amount of scaffolding and a crane at the top in this view looking east. Also shown are the cable bents that support the main cables as they bend downward toward the east anchor house. (Courtesy City of Portland Archives.)

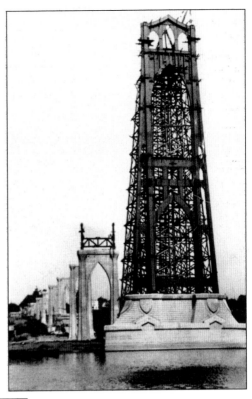

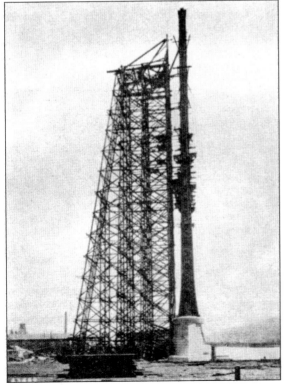

The east tower is shown near completion, with the timber scaffolding in place in this photograph. Numerous temporary platforms are visible at various levels on the tower, which reaches 408 feet, seven inches above low-water level. The timber scaffolding for the St. Johns Bridge's two towers consumed 250,000 board feet of timber. (Courtesy Multnomah County Library.)

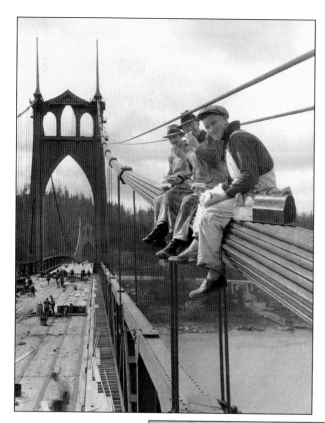

Workmen are eating lunch on one of the main cables in this view looking west. The first 2,720-foot main cable strand was pulled across the river by cable contractor John A. Roebling's Sons, Inc., on October 15, 1930. Each strand is a cable one and one-half inches in diameter, and each main cable contains 91 strands. (© Ingham Photo, Inc.)

One of the main cables is being wrapped with piano wire in this view, dated April 2, 1931. The 91 strands that make up each main cable were formed into a 16-and-one-half-inch-diameter hexagon, covered with specially shaped pieces of Port Orford cedar that make a round outer surface, and wrapped with piano wire. (Courtesy Multnomah County Library.)

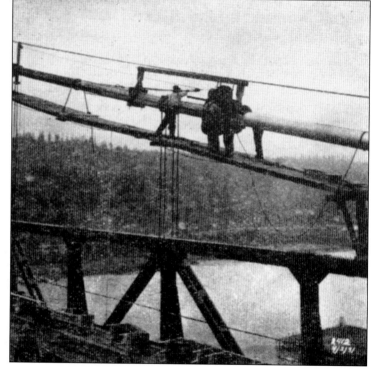

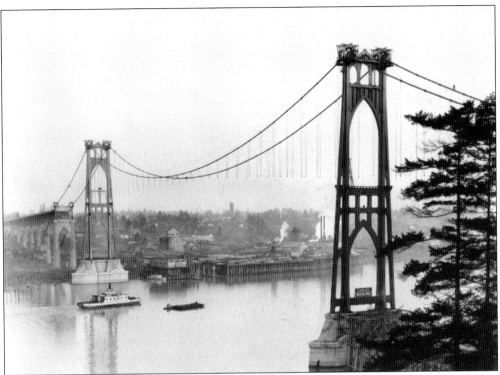

In this view looking toward the southeast, the St. Johns ferry passes beneath the bridge and the towers and main cables of the St. Johns Bridge are complete. The suspender cables are all attached to the main cables. A sign below the west tower declares that the cables were supplied by John A. Roebling's Sons, Inc. (Courtesy City of Portland Archives.)

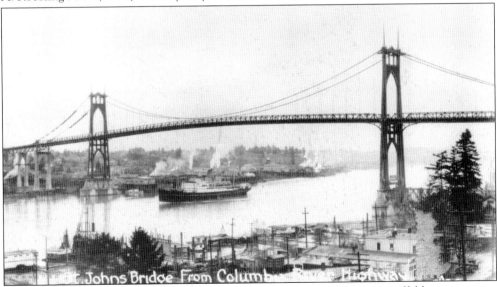

The St. Johns Bridge is near completion in this undated view, with some scaffolding remaining near the top of the towers, some sections of the walkway remaining on the main cables to the left, and Roebling's sign remaining near the bottom of the west tower. Four graceful, copper-covered, 50-foot spires cap the Gothic-style towers. (Courtesy City of Portland Archives.)

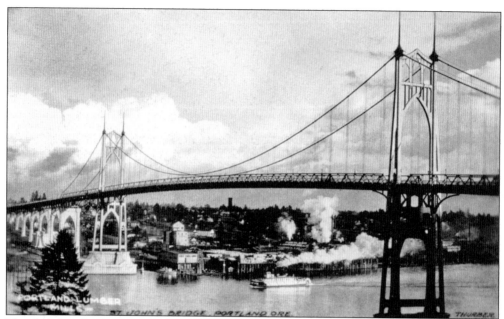

The St. Johns Bridge, a riverboat, and some of Portland's lumber mills are shown in this view looking southeast. The bridge, opened on June 13, 1931, is Portland's only major suspension bridge and has a main span of 1,207 feet. It was the longest suspension bridge west of Detroit, Michigan, a record lost by the time California's Golden Gate Bridge was finished. (Courtesy author.)

The St. Johns Bridge was celebrated by this float as part of the June 12, 1931, Grand Floral Parade of the Portland Rose Festival. The formal dedication was on June 13 and included addresses by the bridge's designer David Steinman and other notable speakers; the opening of the bridge by the Queen of Rosaria, Rachel Florence Atkinson; and a dedication parade across the bridge. (Courtesy Nelson family archive.)

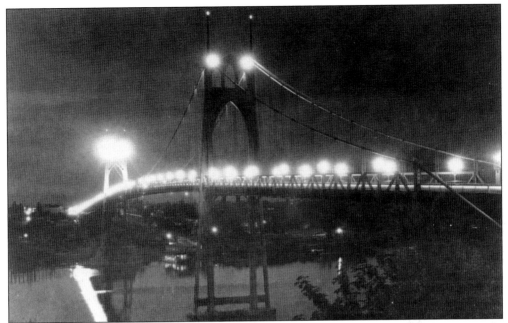

The St. Johns Bridge's street lighting, navigation lighting, and aviation lighting is shown at night in this undated photograph. The navigation lighting consists of green lights marking the bottom of the structure at the center of the navigation channel and red lights marking the edges of the navigation channel. The aviation lights mark the top of the spires for pilots. (Courtesy City of Portland Archives.)

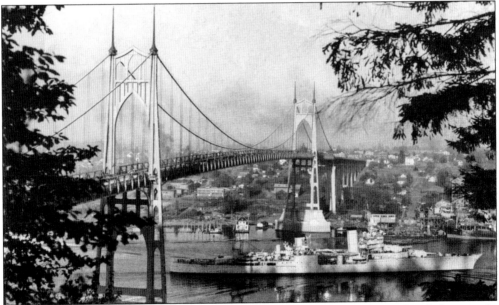

The heavy cruiser USS *Portland* passes under the St. Johns Bridge in this undated photograph. The *Portland*, which was named for the city of Portland, Maine, was laid down by Bethlehem Steel Company in Quincy, Massachusetts, on February 17, 1930; launched on May 21, 1932; and commissioned on February 23, 1933 with Capt. H. F. Leary in command. (Courtesy Curtis B. Cryer.)

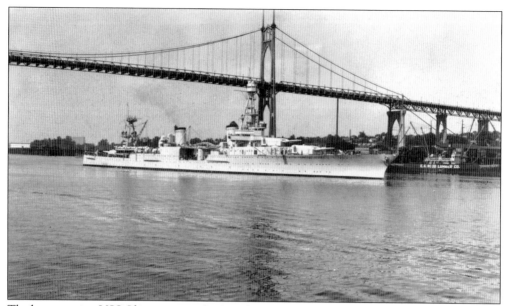

The heavy cruiser USS *Chicago* passes the St. Johns Bridge in this undated photograph. The bridge provides 203 feet and 6 inches of vertical clearance over the navigation channel at low water. The *Chicago* was commissioned March 9, 1931, with Capt. M. H. Simmons in command. The *Chicago* was sunk on January 27, 1943, while escorting a Guadalcanal convoy. (Courtesy author.)

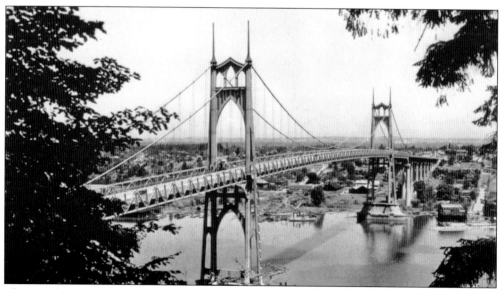

The St. Johns Bridge is shown during a lull in activity in this view from a popular vantage point, framed by the leaves of trees on the west approaches. There are no vessels traveling on the river, and there is little vehicular traffic on the bridge, making for a peaceful scene. (Courtesy author.)

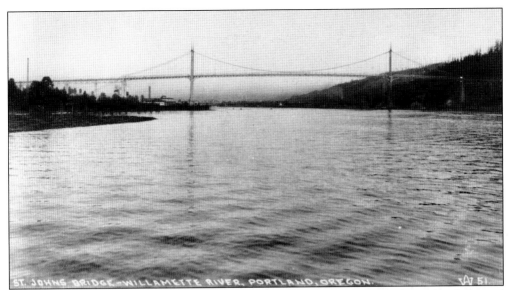

The St. Johns Bridge appears particularly graceful from the water as shown in this undated postcard view looking upriver toward downtown Portland. The bridge is Portland's only suspension bridge, although Oregon City, 20 miles upstream, had a suspension bridge over the Willamette River from 1888 through 1922. (Courtesy Stephen Kenney Jr.)

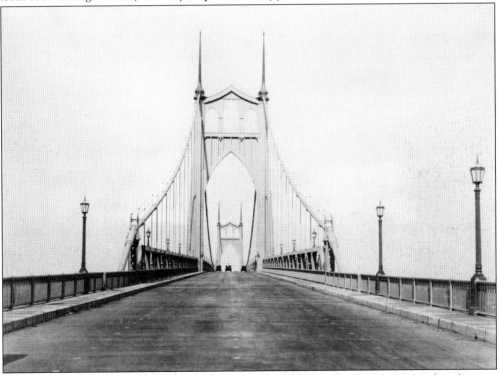

This early roadway view of the St. Johns Bridge shows the opposite tower, framed within the near tower's main Gothic-arch opening. Also shown are the bridge's graceful Gothic-style spires and secondary arched openings, its steel handrail, and its ornate street lights. The bridge provides four 10-foot lanes and two 5-foot sidewalks. (Courtesy ODOT.)

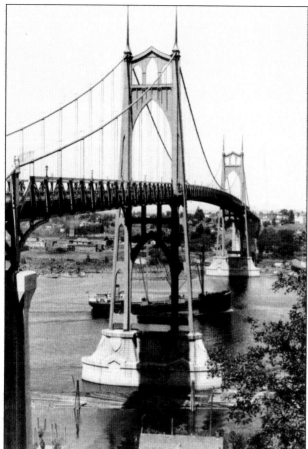

The St. Johns Bridge is lit by the sun in this view. The bridge's designer preferred a green color that would harmonize with Portland's nearby Forest Park. Aviation interests from the Portland Airport, at Swan Island, proposed black and yellow stripes instead. However, on March 17, 1931, Saint Patrick's Day, the Multnomah County Commission announced that the bridge would be verde green. (Courtesy City of Portland Archives.)

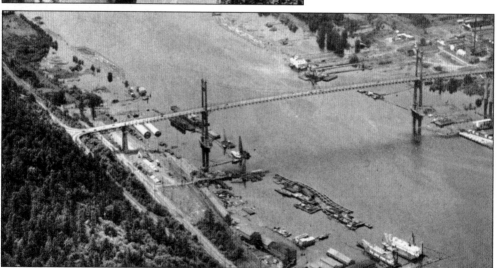

The St. Johns Bridge is shown during the Vanport flood in this photograph, dated June 17, 1948. To the left in this view is Portland's Forest Park, which covers this part of the steep West Hills. The west end of the 3,834-foot bridge terminates in a T-shaped intersection at the foot of the hills. (Courtesy City of Portland Archives.)

Seven

MARQUAM BRIDGE

Oregon State Highway Department model builders Jacques Bergman, at left, and Bill Cranford, at right, created this model of the Marquam Bridge, which was displayed at the United States National Bank of Portland in August 1961. The model took about 33 months to complete and was used to resolve traffic-engineering issues. The Marquam Bridge, located between the Hawthorne and Ross Island Bridges and carrying Interstate 5, was completed in 1966 with a 1,043-foot, three-span, double-deck continuous truss section over the river with some steel plate girder approach spans and some prestressed concrete girder approach spans. The main span over the navigation channel spans 440 feet and provides 120 feet of vertical clearance. The bridge provides a roadway width of 57 feet and no provisions for pedestrians. The Marquam Bridge was designed by Oregon State Highway Department engineers. The concrete piers were constructed by Peter Kiewit Sons' Company, and the steel-truss spans and steel-plate-girder spans were built by American Bridge Division of United States Steel Corporation of Pittsburgh, Pennsylvania. (Courtesy ODOT.)

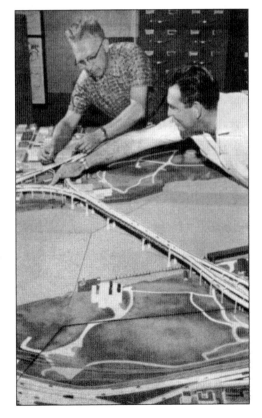

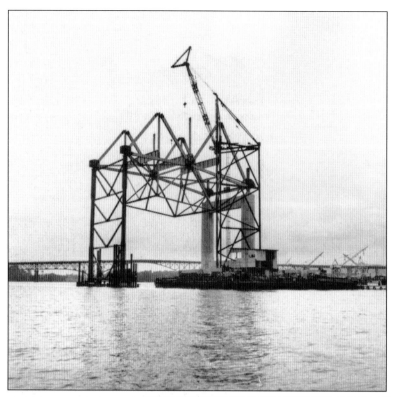

The early stages of steel erection are shown in this view looking south, dated July 2, 1964. Three floor beams for the lower deck and a series of truss members are supported by a temporary truss mounted on the pier and a temporary tower. A second tower mounted on a barge supports the crane being used to erect the truss members. (Courtesy ODOT.)

Truss construction for the Marquam Bridge is now progressing toward the navigation channel in this photograph, dated July 29, 1964. The barge-mounted tower crane is placing lower lateral members, a floor beam for the upper deck is visible, and some floor stringers have been placed on the lower deck floor beams. (Courtesy ODOT.)

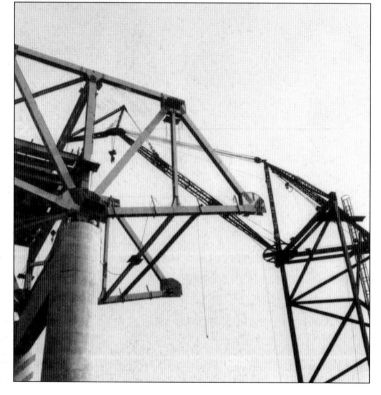

Several workers are shown on top of the truss in this photograph, dated November 5, 1964. The workers have a cable strung between temporary stanchions for their safety. At lower right, a steel connection awaits the installation of more truss members, and the upper and lower floor framing is progressing as the trusses are extended. (Courtesy ODOT.)

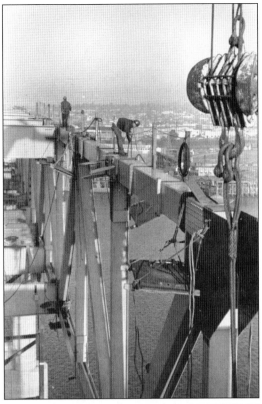

Work continues on the main cantilever-truss span and the west approaches in this undated photograph looking toward the north. Construction of the east approaches lagged due to a stalemate in right-of-way negotiations between the Oregon State Highway Department and Portland Traction Company, which was owned by the Union Pacific and Southern Pacific Railroads. (Courtesy City of Portland Archives.)

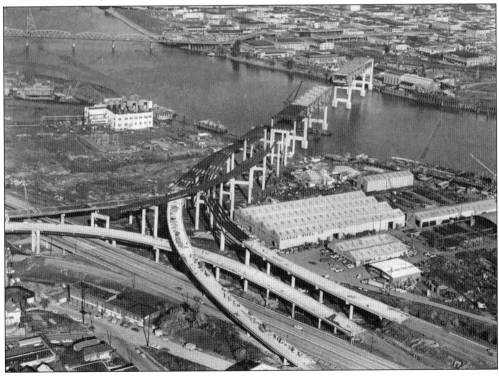

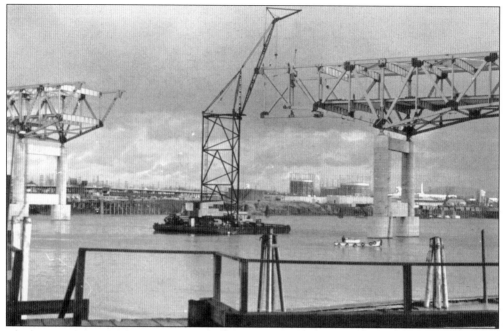

The barge-mounted tower crane is placing upper-truss members above the navigation channel in this view, dated December 2, 1964. The top deck is 165 feet above low water, and the lower portions of the truss allow for 120 feet of vertical clearance above low water. The vertical clearance was originally proposed at 96 feet, 7 inches, which was protested by a group of navigation interests. (Courtesy ODOT.)

The floor framing for this section of the lower deck appears complete in this photograph, dated December 11, 1964. At left, panels have been placed to create a walkway, complete with a cable handrail. Panels have also been placed in the center, which provide space for a few supplies. (Courtesy ODOT.)

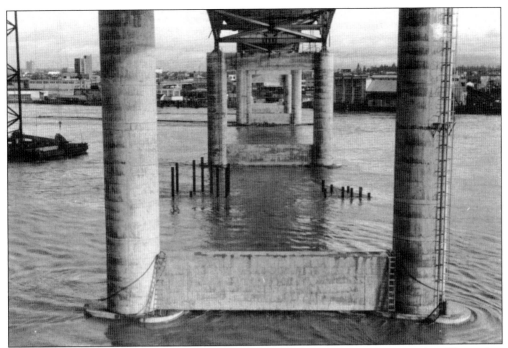

Pilings from the temporary erection tower have not yet been removed in this view, dated December 24, 1964. This was the date of a major Willamette River flood rivaling the infamous Vanport flood of 1948, and the waters have nearly covered the lower, larger diameter portion of the columns and are nearly touching the lower crossbeams of the bents. (Courtesy ODOT.)

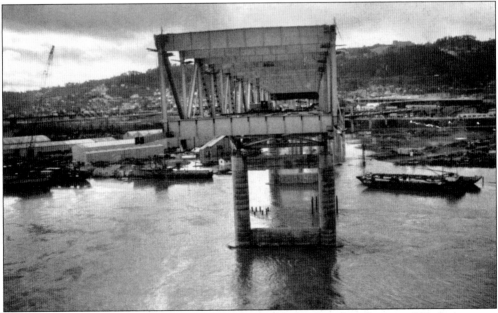

The gap between the halves of the main span is highlighted in this photograph looking across the navigation channel on December 24, 1964. The floor beams are slightly thicker at the center of the roadway to provide a slight crown in the surface of the deck, which keeps rainwater from accumulating in the traffic lanes. (Courtesy ODOT.)

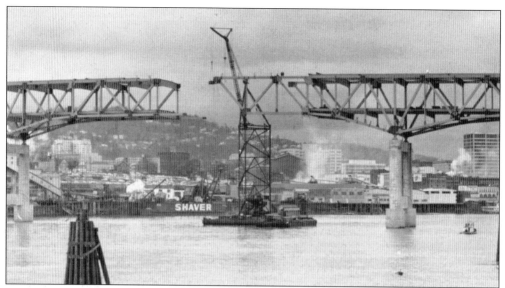

The barge-mounted tower crane is placing truss members of the main span over the navigation channel, which is nearly connected in this photograph, taken January 6, 1965. On July 11, 1965, a 50-ton, U-shaped support frame and two upper-deck braces deflected during a concrete pour, prompting a halt of construction. Construction work continued after reinforcing these components. (Courtesy ODOT.)

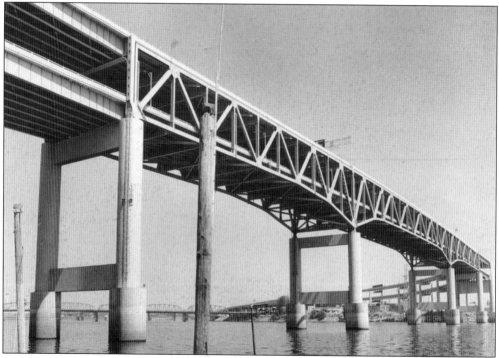

The completed Marquam Bridge is shown in this view looking toward the northeast. The bridge was finished on February 28, 1966, and the upper deck was opened to traffic on October 18, 1966. With the opening of the Marquam Bridge, Interstate 5 became an unbroken freeway through Oregon, from California to Washington. (Courtesy ODOT.)

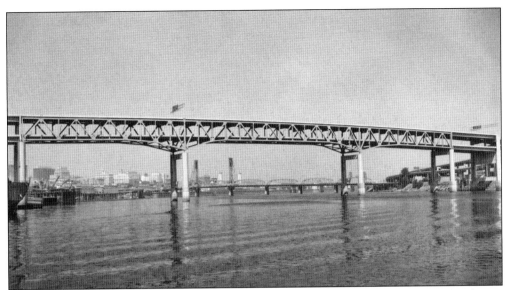

The completed Marquam Bridge is shown in this view looking north with the Hawthorne Bridge in the background. This photograph shows Portland's newest and oldest bridges for motor-vehicle traffic. Average daily traffic on the Marquam Bridge was 40,000 vehicles within two months of opening, and average daily traffic on the Steel Bridge was reduced by 20,000 vehicles. (Courtesy ODOT.)

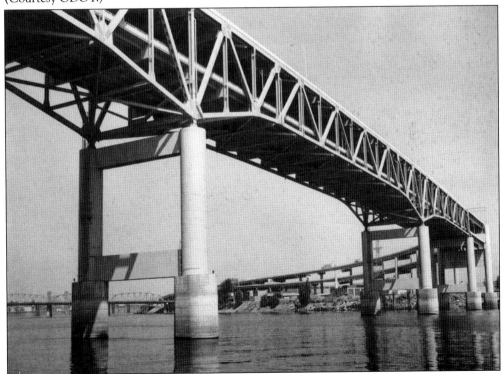

The east approaches of the Marquam Bridge are visible in this view of the bridge looking northeast. The ramps to Interstate 5 are similar to those shown on page 97, but the other ramps that would have led south from the east end of the bridge were not built. (Courtesy ODOT.)

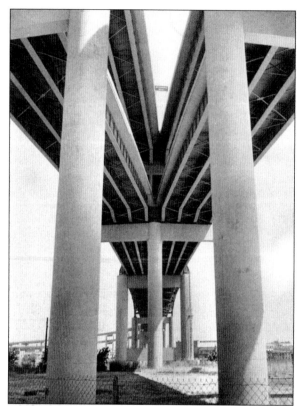

The underside of the west approaches to the Marquam Bridge is shown in this undated view looking northeast. Each of the various ramps shown is of steel-plate-girder construction atop tall reinforced-concrete bents. The total cost of the Marquam Bridge, including east and west approaches, was $11 million. (Courtesy ODOT.)

The double-deck Marquam Bridge with its many ramps, several unfinished, is shown in this May 11, 1973, view. This important bridge's "erector set" appearance prompted the Portland Arts Commission to complain to Gov. Mark O. Hatfield that it "is so gross, so lacking in grace, so utterly inconsistent with any concept of esthetics that the Art Commission feels called upon to offer a formal protest." (Courtesy ODOT.)

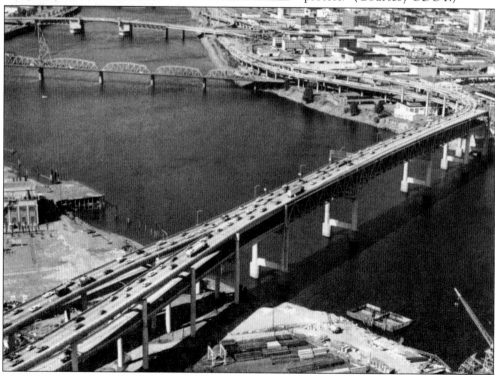

Eight

FREMONT BRIDGE

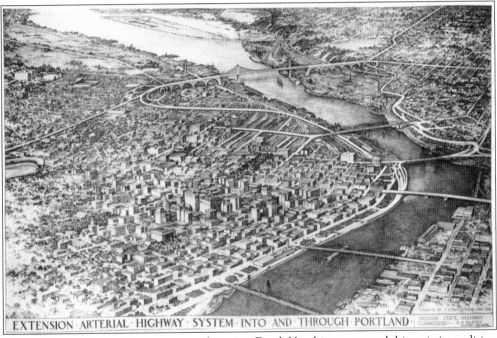

EXTENSION · ARTERIAL · HIGHWAY · SYSTEM · INTO · AND · THROUGH · PORTLAND

Oregon State Highway Department graphic artist Frank Hutchinson created this artistic rendition of a proposed bridge and highway in June 1939. The suspension bridge with reinforced-concrete-arch approach spans would have been near the future site of the Fremont Bridge, approximately 3,000 feet downstream from the Broadway Bridge. Also visible are the Portland Airport, on Swan Island just downstream, and the Lovejoy Viaduct approach to the Broadway Bridge. When actually built in the late 1960s and early 1970s, the bridge became a double-deck, steel-part-through-tied-arch structure with a record 1,255-foot main span providing 175 feet of vertical clearance for navigation, and the highway became Interstate 405. The public outcry over the aesthetic qualities of the Marquam Bridge greatly influenced the design of the Fremont Bridge, which was designed by consulting engineers Parsons, Brinckerhoff, Quade and Douglas of New York and built by Murphy Pacific Corporation of Emeryville, California. (Courtesy ODOT.)

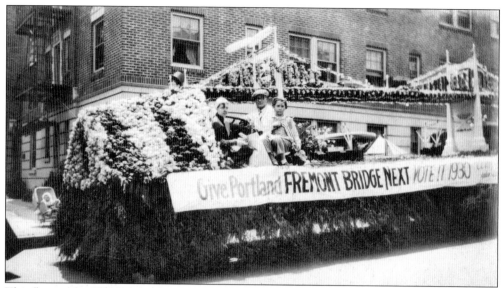

This float in the 1930 Portland Rose Parade promoted the Fremont Bridge as a suspension bridge. Large bridge projects are often very slow and laden with politics. Typically it is difficult to agree on the need for a bridge and its proper location. Over 40 years elapsed before the Fremont Bridge became a reality. (Courtesy Nelson family archive.)

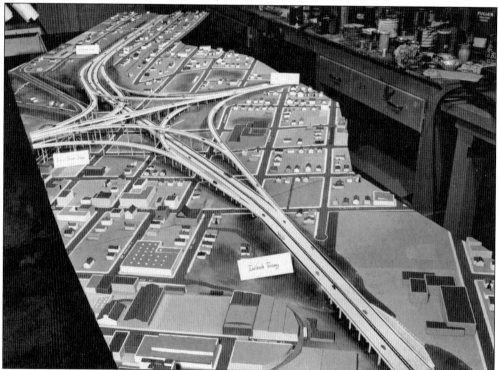

This model of proposed freeway connections at the east end of the Fremont Bridge was made in 1962. The "Proposed Fremont Freeway" and many of the connections to the east were not built, but most of the connections to Interstate 5, shown as the "Eastbank Freeway" and "Minnesota Freeway" were built with the Fremont Bridge. (Courtesy City of Portland Archives.)

The excavation of the east main pier is shown in this photograph, dated October 26, 1968. The contractor, Peter Kiewit Sons' Company, built an earthen dike along the river bank and pumped out the excavation as shown at lower left. After excavation, 360 foundation pilings were driven, compared with 672 smaller pilings at the west main pier, which was constructed in a sheet-piling cofferdam. (Courtesy ODOT.)

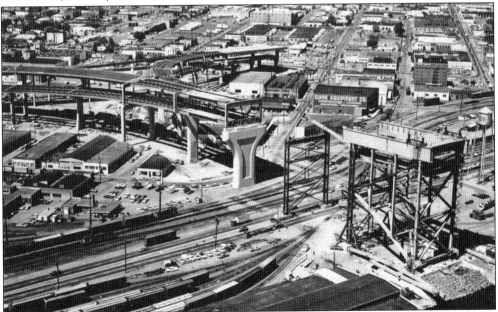

The west side span of the steel arch is being erected on temporary supports in this view, dated June 21, 1971, looking toward the west approaches. Sections of the tie girders are in place atop steel columns, and several sections of arch ribs and tie girders are waiting on the ground. A worker is climbing the temporary stairway from the pier to the roadway deck. (Courtesy ODOT.)

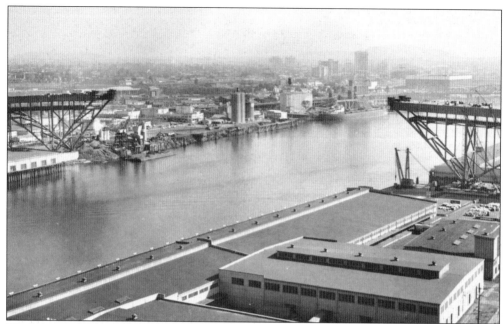

The Fremont Bridge looked like this for approximately a year, waiting for delivery of the 902-foot, center-arch section. The temporary jack emplacements at each corner of the center-arch section appear to be under construction in this 1973 view. A ship is docked at a grain terminal on the east bank of the Willamette River toward the Broadway Bridge to the south. (Courtesy ODOT.)

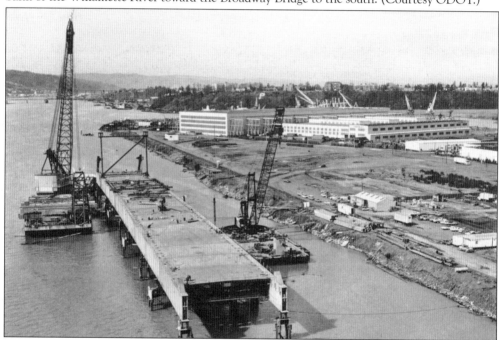

Assembly of the 900-foot center span began late in 1971. The center span is shown with tie girders and deck assembled on pilings at contractor Murphy Pacific Corporation's yard at Swan Island in this view, dated March 7, 1972. The Murphy Pacific derrick barge *Marine Boss* and another barge-mounted crane are anchored alongside. (Courtesy ODOT.)

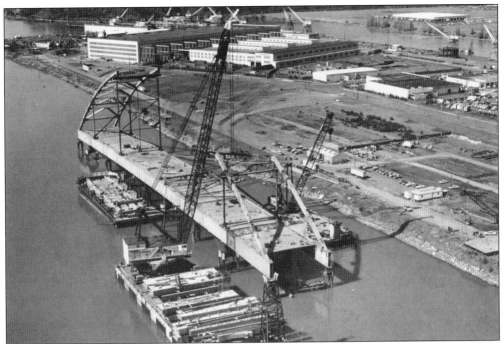

The arch ribs reach above the roadway deck of the 900-foot center span in this photograph, dated March 29, 1972. Three of the temporary supports that held the arch ribs in place during assembly are visible. Before erecting the arch ribs, the tie girder and roadway deck were cambered upward approximately 18 inches to compensate for later downward deflections, as the weight of the bridge increased during assembly. (Courtesy ODOT.)

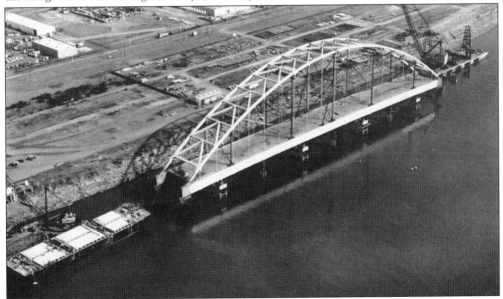

The structural steel for the 902-foot, center-arch section of the Fremont Bridge was fabricated in California and assembled at Murphy Pacific Corporation's Swan Island yard. This 1973 view shows the nearly completed arch at Swan Island, still supported by pilings. The arch was later mounted on barges for the 1.7-mile trip to the bridge-construction site. (Courtesy ODOT.)

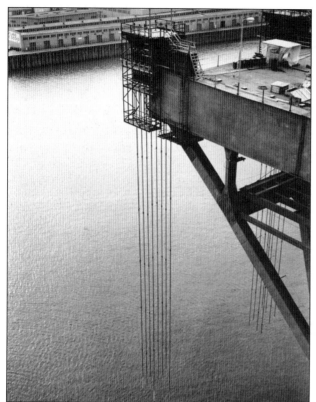

Eight four-inch-diameter, high-strength, steel-threaded rods are being installed at each corner of the center span to lift the 6,000-ton span in this close-up view, dated March 8, 1972. Each rod will be connected to a 200-ton hydraulic jack. The structural frames for jacking are covered by an elaborate system of platforms and ladders, and the top of the threaded rods appears to protrude through the platforms. (Courtesy ODOT.)

One of the control panels for the 200-ton jacks is shown in this view. The jacks were made by the William S. Pine Division of Templeton, Kenly and Company, and the jacking system was designed by the contractor Murphy Pacific Corporation, with their erection consultant, Earl and Wright, and the jack manufacturer. (Courtesy ODOT.)

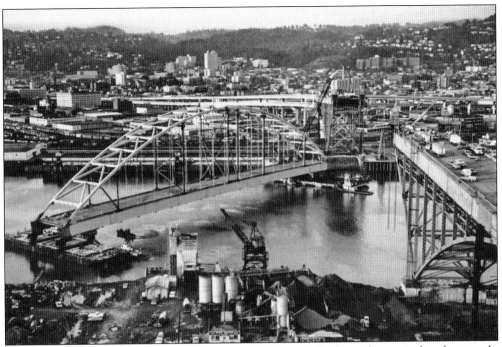

The center span is being brought into position at the Fremont Bridge on barges in this photograph, dated March 14, 1973. A fleet of six tugs was used to move the center span 1.7 miles from Swan Island. Most of the temporary supports for the arch ribs are still in place. (Courtesy ODOT.)

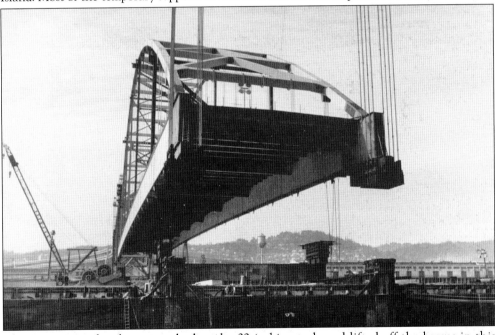

The center span has been attached to the 32 jacking rods and lifted off the barges in this photograph, taken March 15, 1973. The 32 jacking rods were each tested to 300 tons, and then lifting began at midnight on March 14 and proceeded at four feet per hour for the next 40 hours. (Courtesy ODOT.)

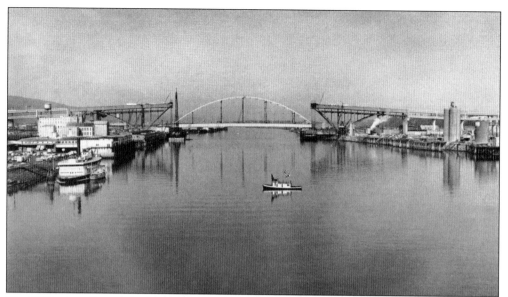

The Willamette River was closed to navigation during the record-breaking lift of the center span, and few vessels are present in this view, dated March 16, 1973. During the lift, the center span was kept within two feet of level from end to end and within one and one-half inches of level from side to side. (Courtesy ODOT.)

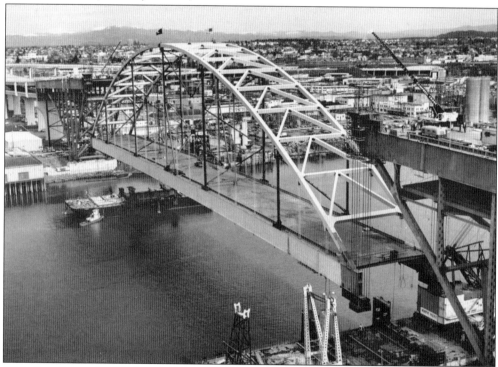

With flags flying, the 902-foot, 3,000-ton, center-arch section of the Fremont Bridge is being lifted 175 feet into position in this March 16, 1973, view looking east. Murphy Pacific Corporation's derrick barge *Marine Boss* is under the west end of the span, and the *Florence* is under the east end of the span. (Courtesy ODOT.)

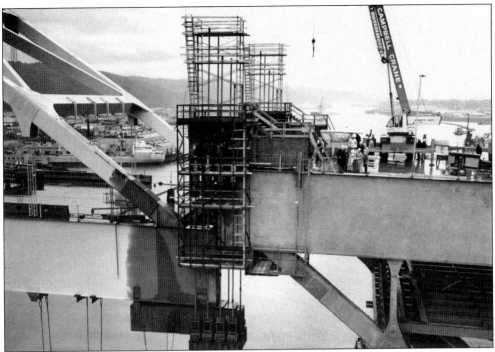

One of the massive welded-steel brackets attached to the tie girders to connect with the jacking rods is clearly visible in this photograph, taken March 16, 1973, near the end of the record-breaking lift. The size of the 18-foot-deep, 50-inch-wide tie girders is evident in this view. (Courtesy ODOT.)

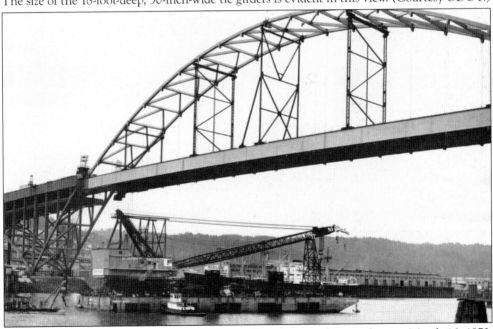

Forty hours of lifting was nearly finished when this photograph was taken on March 16, 1973. Murphy Pacific Corporation's derrick barge *Marine Boss* is taking a well-deserved rest. When the record-breaking center span lift was completed, Murphy Pacific suspended construction operations for the weekend to give their crews an equally well-deserved rest. (Courtesy ODOT.)

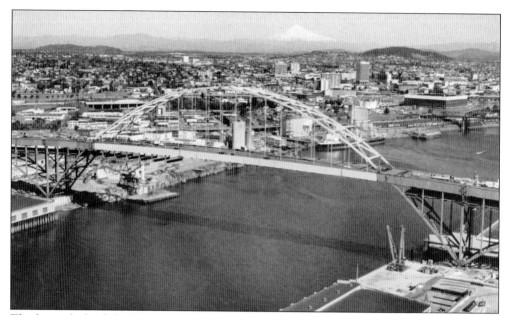

The lower deck of the Fremont Bridge is under construction in this May 1, 1973, view, which also shows Mount Hood and a portion of east Portland. An array of equipment and supplies is parked on the upper deck, and some of the floor beams for the lower deck have been installed. (Courtesy ODOT.)

Ramps connecting the Fremont Bridge to northwest Portland are shown in this view. These ramps are built on steel-box girders supported by massive reinforced-concrete frame bents. Portions of the approaches are also supported by large, steel box-beam frame bents. The Fremont Bridge carries a total of 14.12 lane miles, with 3.27 lane miles on the bridge and 10.85 lane miles on its approaches. (Courtesy ODOT.)

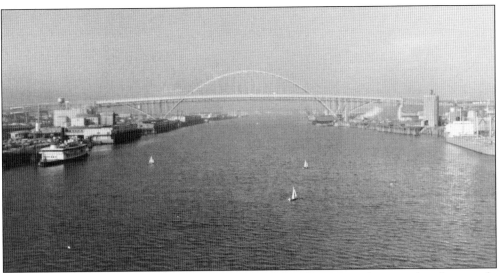

The Fremont Bridge is a graceful tied arch with half-arch side spans, as shown in this photograph, taken October 2, 1973, from upriver. On November 11, 1973, about 25,000 to 30,000 people attended opening ceremonies on the bridge. The ceremonies, sponsored by Portland radio station KGW, offered attendees a chance to walk on the bridge before motorized traffic was allowed. (Courtesy ODOT.)

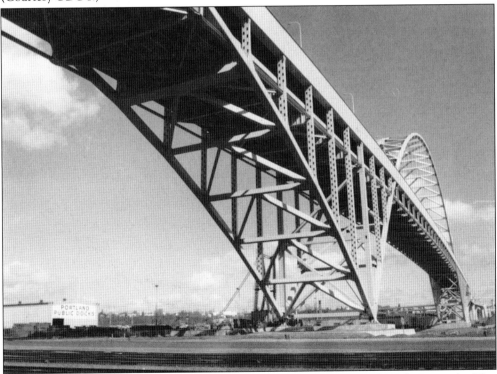

The completed Fremont Bridge is shown from ground level in this view from the west side. This beautiful bridge, which is 7,312 feet long and has a 1,255-foot main span, cost $82 million. There was one fatal accident during construction, when worker Leo Marmolaja fell approximately 45 feet during a scaffold collapse in May 1970 on the West Fremont Interchange. (Courtesy ODOT.)

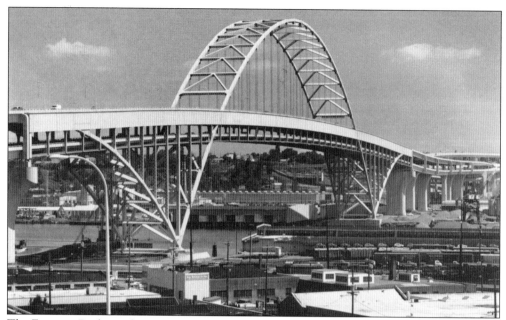

The Fremont Bridge is shown in this view looking toward the northeast. On October 28, 1971, before the center span was installed, a six-foot-long crack appeared in the tie girder where it connects to the half-span arch rib at the far left. The arch-rib connection was redesigned to reduce stresses, particularly stresses induced by welding, and four connections were repaired at a cost of $5.5 million. (Courtesy ODOT.)

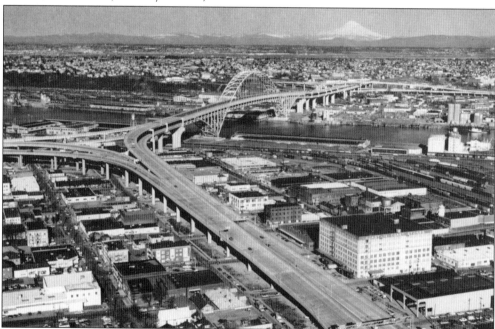

Most of the complex of ramps and approaches that connect with the Fremont Bridge are shown in this view looking northeast toward Mount St. Helens. On May 17, 1976, American and bicentennial flags were installed at the top of the arch by a helicopter. A few years later, on May 18, 1980, Mount St. Helens lost its peak in a volcanic eruption. (Courtesy ODOT.)

Nine

GLENN L. JACKSON MEMORIAL BRIDGE

This artist's rendition shows an early design for the Glenn L. Jackson Memorial Bridge, named for the Oregon Transportation Commissioner who pushed the state's interstate highway system to completion. The bridge's primary architectural feature is the graceful thinning of the structure from 32 feet thick at the main piers to 17 feet thick at the center of the main span. Planning for the bridge began as early as 1950, with a 1967 study rejecting a tunnel due to its very high cost, and continued later with efforts to move the bridge site east to improve clearance for the nearby Portland International Airport while providing adequate clearance for the navigation channel. Groundbreaking for this important link in Interstate 205, Portland's east-side bypass, was August 23, 1977, aboard Willamette-Western Corporation's dredge *Titan*. The 11,750-foot-long structure, with its estimated $175.2 million price tag, consumed 250,000 cubic yards of embankment material, 60,000 cubic yards of riprap, 320,000 cubic yards of concrete, 21,000 tons of reinforcing steel, 6,000 tons of prestressing steel, and 280,000 lineal feet of steel piling. (Courtesy ODOT.)

The river is busy with construction activity in this view showing numerous piers under construction. At left, steel "H" section sheet pilings are being driven to form a cofferdam. Near the center, a barge-mounted pile driver is driving foundation pilings in a cofferdam, and, at right, steel-column reinforcement reaches high above a cofferdam. Water is being pumped from the lower right cofferdam. (Courtesy ODOT.)

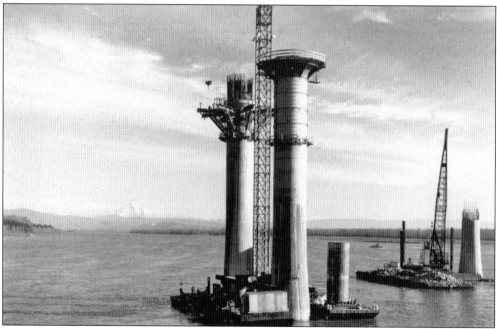

In this view looking toward Mount Hood, two columns are nearly complete and temporary supports are being installed on one column for box-girder formwork. Next to the column at right, excavation for the column's twin is underway within its cofferdam loading the barge with excavated material. In March 1979, worker William J. Kenneday was fatally injured in a fall from a bridge pier. (Courtesy ODOT.)

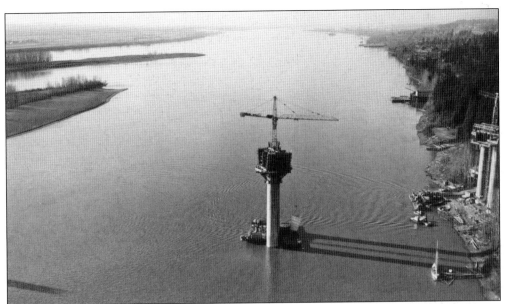

Box-girder formwork is in place in this view looking downriver. The north-channel foundations and columns were built by a joint venture of Willamette-Western Corporation, Alaska Constructors, Inc., and General Construction Company. Willamette-Western Corporation became Reidel International Corporation while completing this bridge. The north-channel, box-girder superstructure was built by a joint venture of S. J. Groves and Sons Company and Guy F. Atkinson Company. (Courtesy ODOT.)

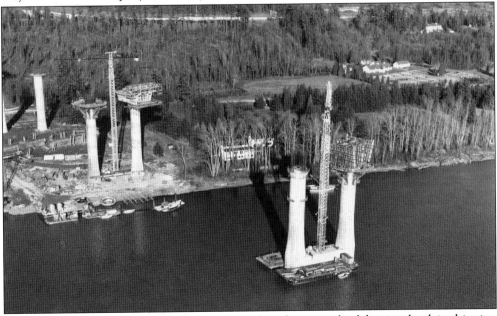

The first segment of box girder has been cast on the column north of the river bank in this view looking northeast. Special travelers made by VSL Corporation of Los Gatos, California, were used to cast the box girders in place, and numerous cycles of forming, casting, and curing took place before the box-girder superstructure would span the full 480-foot distance between the center lines of the piers. (Courtesy ODOT.)

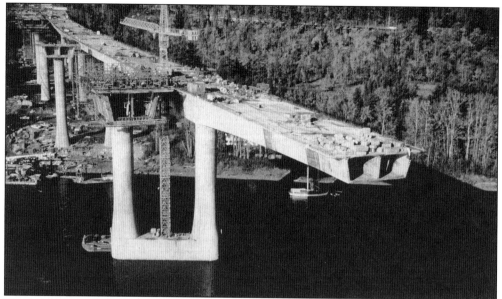

The box-girder superstructure is now continuous over the 480-foot span from the pier on the river bank to the first in-water pier and is reaching to span the 600-foot main navigation channel in this view looking northeast. The blocks piled on the free end of the box girder are probably weights to help align the 480-foot span for the last concrete pour. (Courtesy ODOT.)

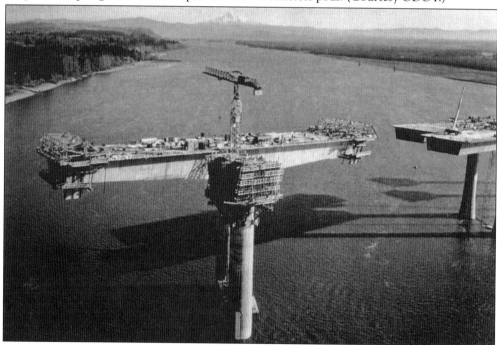

The main pier south of the navigation channel is shown in this view looking southeast toward Mount Hood. This view illustrates the "balanced cantilever" method of segmental construction, in which segments are added extending both ways from the pier so that the weight is nearly balanced on the pier. The 480-foot span south of the navigation channel is nearly connected. (Courtesy ODOT.)

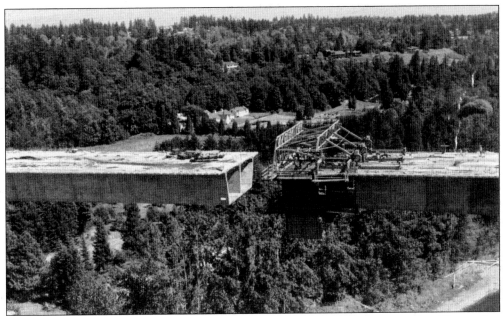

The Glenn L. Jackson Bridge's 600-foot main span is nearly joined in this view, dated September 4, 1980. Once completed, the concrete box girders are strengthened by post-tensioning, which is the use of high-strength steel tendons placed in ducts in the concrete and stretched to put pressure on the concrete. In December 1980, workers Louis Gregory and Robert Kirby were fatally injured in a crane collapse. (Courtesy ODOT.)

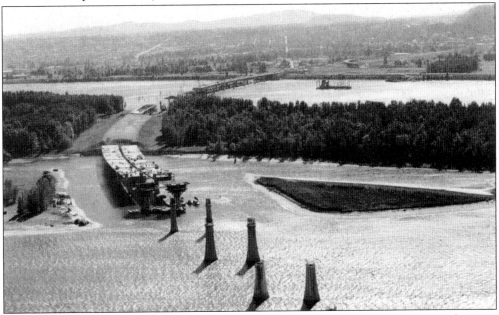

The south part of the main channel bridge and the south channel bridge are shown in this view looking south. The south channel bridge was constructed by Willamette-Western Corporation using traditional falsework, the numerous supports beneath that section's box girders. The south part of the main channel bridge was constructed using precast concrete segments 8- to 12-feet long and weighing 120 to 190 tons each. (Courtesy ODOT.)

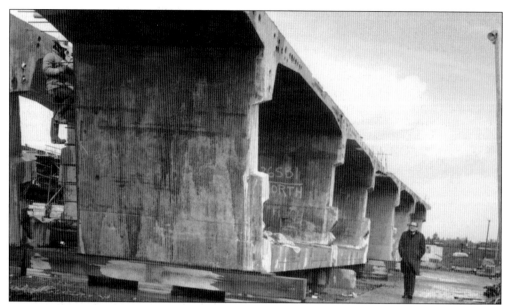

Several of 592 precast-concrete segments are shown here in the yard. The precast segments were produced in 12-foot, 15-foot, and 17-foot depths at a location four miles downstream. The segments were temporarily held in place by high-strength threaded rods. Once all segments were in place, tendons were installed in the ducts, visible near the top, and post-tensioned. (Courtesy ODOT.)

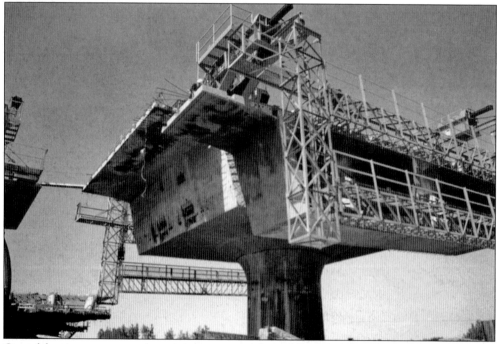

One of the precast-concrete box-girder segments is being lifted into place by an elaborate hoisting system in this view. The hydraulic hoisting system, which held the segment in alignment two feet from the adjacent segment while concrete was poured between them, was designed and built by Morgan Manufacturing Company of Portland. (Courtesy ODOT.)

The "Columbia Crossing '83" is shown from the Oregon shore looking toward Government Island in this photograph, dated May 15, 1983. By some accounts, 200,000 people either watched or participated in the road race to celebrate the public opening of the bridge. Runners are visible on both sides of the Glenn Jackson Bridge and Marine Drive below. (Courtesy ODOT.)

The Washington approach, which was built by Peter Kiewit Sons' Company, is included in this view of the entire bridge looking toward the south. The bridge was controversial in several respects. The standard bridge rail seemed too short to some motorists, Portland's Fire Chief criticized the lack of hydrants, and plans to close Rocky Butte Jail to make room for I-205 were criticized as other jails neared capacity. (Courtesy ODOT.)

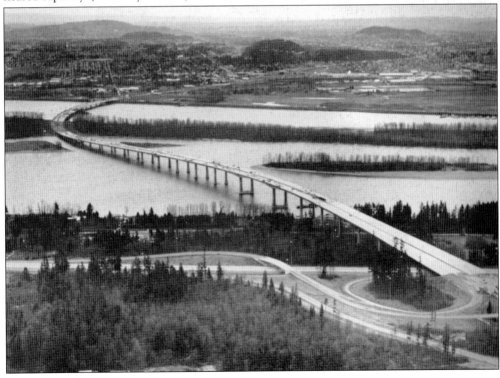

The completed Glenn L. Jackson Bridge, the last link in Oregon's interstate highway system, opened for traffic on December 15, 1982. Allan C. Harwood served as project engineer for the Oregon State Highway Division, James A. Brosio served as the resident engineer for the Washington Department of Highways, and Howard Harris and John Howard served as project managers for the Oregon State Highway Division. (Courtesy ODOT.)

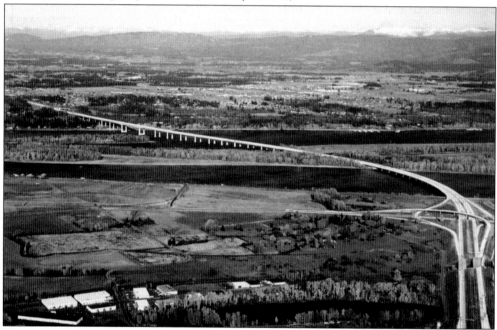

The entire Glenn L. Jackson Bridge is shown in this November 22, 1982, view, which also shows Portland's Airport Road and Mount St. Helens in the distance. The larger bridge over the main channel was designed by Sverdrup and Parcel and Associates of Bellevue, Washington, while the bridge over the south channel was designed by Oregon State Highway Department engineers. (Courtesy ODOT.)

A United Airlines Boeing 727 flies over the south-channel bridge on approach to Portland International Airport in this May 4, 1983, photograph. During design, the bridge site was moved to the east to accommodate the airport while providing 144-foot vertical clearance for navigation on the Columbia River. (Courtesy ODOT.)

In May 1984, the American Society of Civil Engineers honored the bridge with an "Outstanding Civil Engineering Achievement" award. Shown with the bronze plaque are, from left to right, H. Scott Coulter, Oregon State Highway engineer; David Driscoll, American Society of Civil Engineers Oregon Section president; Robert F. Dwyer, Oregon transportation commissioner, 1981–1987; and Samuel T. Naito, Oregon transportation commissioner, 1983–1987. (Courtesy ODOT.)

BIBLIOGRAPHY

"Advancing into a New Generation." *Engineering News Record.* April 2, 1981.

Bolton, Eric. "Portland's Triumphant Arch." *Constructor.* October 1975.

"Bridge Dedication Number Commemorating the Dedication of the St. Johns Suspension Bridge, As an Event of the Portland Rose Festival, Saturday, June 13, 1931." *St. Johns Review.* Portland, Oregon: June, 1931.

Carter, Byron B. "The Operating Machinery of the Willamette River Drawbridge, Near Portland, Oregon." *Journal of the Western Society of Engineers.* September 1916.

Glomb, Jozef. *A Man Who Spanned Two Eras, The Story Of Bridge Engineer Ralph Modjeski.* The Philadelphia Chapter of the Kosciuszko Foundation, 2002.

Harrington, John Lyle, and Ernest E. Howard. *Final Report, The Columbia River Interstate Bridge, Vancouver, Washington to Portland, Oregon, for Multnomah County, Oregon, and Clark County, Washington.* John Lyle Harrington and Ernest E. Howard, Consulting Engineers. Kansas City, Missouri: 1918.

"Interstate Bridge Alteration." *Pacific Builder and Engineer.* March 1959.

"Joint Redesign on Cracked Box Girder Cuts into Record Tied Arch's Beauty." *Engineering News Record.* March 30, 1972.

Klopfenstein, Don and Inez. "Portland's Second Crossing." *Pacific Builder and Engineer.* July 20, 1981.

Library of Congress, Historic American Engineering Record, National Park Service, U.S. Department of the Interior. Portland Bridge Records.

McCullough, Conde B. *Investigation of Morrison Street Bridge, Portland, Oregon.* Oregon State Highway Department. Salem, Oregon: April 6, 1920.

Merchant, Ivan D. "Construction of the Columbia River (Portland–Vancouver) Bridges." *Journal of the Construction Division, Proceedings of the American Society of Civil Engineers*. September, 1959.

Portland's Arch of Triumph. Parsons, Brinckerhoff, Quade and Douglas Notes, Spring 1974.

Reed, Melville F. "The New Burnside Bridge, Portland, Oregon." *Western Construction News.* July 10, 1926.

Salem, Oregon. Department of Transportation. History Center. Bridge Files.

Souvenir Views of Portland's Great Flood, June 1894. Peasley Bros. Portland, OR.

"Span Lift Sets New Records." *Western Construction.* June 1973.

"Steel Forms Simplify Construction of Marquam Bridge Piers." *Pacific Builder and Engineer.* March, 1963.

Tokola, Alpo J., and Edward J. Wortman. "Erecting the Center Span of the Fremont Bridge." *Civil Engineering, American Society of Civil Engineers.* July 1973.

Walkin, Bill. *A History Of ESCO Corporation from Its Establishment in 1913 to the Date of Its Golden Anniversary, July 13, 1963.* ESCO Corporation, 1963.

Wood-Wortman, Sharon, and Jay Dee Alley. *The Portland Bridge Book.* Portland, OR: Oregon Historical Society Press, 2001.

http://www.columbian.com

ACROSS AMERICA, PEOPLE ARE DISCOVERING SOMETHING WONDERFUL. THEIR HERITAGE.

Arcadia Publishing is the leading local history publisher in the United States. With more than 3,000 titles in print and hundreds of new titles released every year, Arcadia has extensive specialized experience chronicling the history of communities and celebrating America's hidden stories, bringing to life the people, places, and events from the past. To discover the history of other communities across the nation, please visit:

www.arcadiapublishing.com

Customized search tools allow you to find regional history books about the town where you grew up, the cities where your friends and family live, the town where your parents met, or even that retirement spot you've been dreaming about.

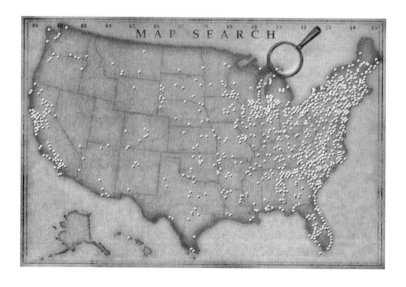